THE ART OF
HANUKKAH

THE ART OF HANUKKAH

by Nancy M. Berman

WITH THE ASSISTANCE OF
Vicki Reikes Fox

Hugh Lauter Levin Associates, Inc.

CONTENTS

Acknowledgments 7

Introduction 9

Cervera Bible 20

Aaron Pouring Oil into the Menorah 22

Lehman/Figdor Lamp 24

Judah the Maccabee
and *Judith and Holofernes* 26

Judith 28

Palazzo Lamp 30

Renaissance Lamp 32

Hannah and Her Seven Sons 34

Heilperin Lamp 36

Star Hanging Lamp
for the Sabbath and Festivals 38

Boller Lamp 40

Pewter Bench-Type Lamp 42

Judith and Holofernes
(from a Book of Blessings) 44

Rintel Lamp 46

18th-Century Dutch Lamp 48

Brody Lamp 50

Polish Brass Lamp 52

North African Lamps 54

"Oak Tree" Lamp 56

Mirror Lamp 58

Hirsch Lamp 60

Rothschild Lamp 62

The Kindling of the Hanukkah Lights 64

Chair Lamp 66

Lighting the Hanukkah Lamp 68

19th-Century Wooden Dreidels 70

Hamsa Lamp 72

Damascene Lamp 74

Synagogue Ark Lamp 76

Mintz Collection Lamp 78

Yemini Lamp 80

Judah the Maccabee Lamp 82

Statue of Liberty Lamp 84

We Kindle These Lights 86

Masada Lamp 88

Natzler Lamp 90

Meier Lamp 92

Los Angeles Lamp 94

Hanukkah Lamp in Four Levels 96

Temple Lamp 98

The Lamp That Burned On 100

From: *Haneirot Halalu:
These Lights Are Holy* 102

Hanukkah in New York 104

Contemporary Dreidels 106

Meander Lamp 108

Hanukkah Still Life 110

In Days of Old, at This Season 112

Menorah and Magnolias 114

Index 116

Photo Credits 119

ACKNOWLEDGMENTS

The art of Hanukkah has occupied a special place in my career as a Jewish museum professional. I was privileged to have had stewardship of the two most artistically exceptional and historically diverse collections of Hanukkah lamps in America, first as Assistant Curator at the Jewish Museum in New York and then for the past twenty-four years as Curator and later Director of the Hebrew Union College Skirball Museum in Los Angeles. These Hanukkah lamps, some beautifully displayed and lit in public galleries, others locked away in crowded and dark storage rooms (to which only I had the key), invited my curiosity, study, introspection, care, and eventually passion. They were the responsible parties in my own progressive attachment to this incredibly hybrid field of art history and Jewish studies. The first exhibition I curated at the Jewish Museum in New York was "Architecture and the Hanukkah Lamp," a subject that was the basis for later exhibitions, articles, and lectures. The new Skirball Cultural Center and Museum, which opened to the public in April 1996, exhibits its proud collection of Hanukkah lamps in the spirit of the ideas in this book.

The Hanukkah lamp was for me the Jewish ceremonial art object that asked the right questions—the questions that stimulated a deeper understanding of the Jewish experience through the art and artifact treasures of the collective Jewish past and present.

In the process of putting this book together, I have had the excellent fortune to benefit from the scholarly assistance of so many of my museum and other academic colleagues, whose expert research and writing on the subject in general and on the particular objects in their curatorial domain have been an important underpinning for this book. In this regard, I acknowledge the important work and sometimes the personal counsel of Lewis Barth, Chaya Benjamin, Susan Braunstein,

Evelyn Cohen, William Cutter, Estelle Fink, Iris Fishof, Izzika Gaon, Barbara Gilbert, Cissy Grossman, Hermann Gundersheimer, Harvey Horowitz, Norman Kleeblatt, Suzanne Landau, Vivian Mann, Yaacov Meshorer, Sharon Liberman Mintz, Sarah Morgan, Bezalel Narkiss, Shalom Sabar, Linda Steinberg, Edward Van Voolen, and Olga Weiss. One cannot write on this subject without appreciation for the scholarly work of Rabbi Philip Goodman, Joseph Gutmann, Stephen Kayser, Franz Landsberger, Mordechai Narkiss, and Guido Schoenberger. Among the collectors who generously participated were Robert and Sandra Carroll, Jacobo Furman, Peachy and Mark Levy, and Linda and Lennard Thal. Thanks are due to many others, including Jan Baum, Herbert Bernhard, Marion and Don Dewitt, Bonnie Grossman, Reva Kirschberg, Elliot Stevens, Stephen Lee Taller, and Alice Yellin.

I also thank Hugh Levin, for the opportunity to write this book, Ellin Silberblatt, the book's editor, who brought expertise, encouragement, and humor along the way, and Sue Warga, for expert copy editing.

A special thanks is due to Grace Cohen Grossman, Curator of the Skirball Museum, whose support and expertise made this book possible, and to Peggy Kayser and Susanne Kester for their able assistance.

Vicki Reikes Fox has been a trusted and active partner, collaborator, and passionate Maccabee (sometimes called "taskmaster" when the book was being finished at Pesach time) in helping me to research, write, edit, and produce a book that will, we hope, increase awareness of the great art treasures of Hanukkah as well as of the treasure that is Hanukkah.

I happily dedicate this book to the "lights of my life"—Alan, Rebecca, and Johanna, who patiently and proudly encouraged me to spend time on this book, knowing that it brought me so much joy. Thank you.

—Nancy M. Berman

INTRODUCTION

The Jewish festival of Hanukkah celebrates a miracle. In an ancient ritual that invites its celebrants to embrace the holiday's message of spiritual and physical redemption, eight burning lights symbolize the light of God, Torah, and life. While each of the Jewish holidays and the Sabbath are consecrated with blessings over lights, only on Hanukkah do Jews kindle lights as the central ritual of observance. The forms of ritual art and works of creative expression inspired by the Hanukkah miracle and the customs of its celebration convey both the profound meaning and the joyful spirit of the Hanukkah festival.

Hanukkah, the Festival of Lights, commemorates the miraculous military victory of a small number of Jews over Syrian oppressors in 165 B.C.E. and glorifies the miracle of a single small cruse of oil that lasted throughout the eight days of the Temple's rededication after the Syrians' defeat by the Maccabees. The holiday's one ritual requirement, observed for over two thousand years, is the lighting and blessing of eight lights to celebrate and proclaim the miracle. Celebrated in the warmth of the home with family and friends, the holiday's customs include lighting the Hanukkah lamp, reciting blessings and psalms, singing songs, eating special foods, playing games of chance, and giving gifts.

THE HISTORY OF HANUKKAH

Hanukkah is the only historically based Jewish festival without an account in the Hebrew Bible. Like the holidays of Passover and Purim, it celebrates an important event in which Jews were delivered from a powerful enemy who sought their destruction. Among the primary sources for this history are 1 and 2 Maccabees, included in the Apocrypha, and Josephus's *History of the Jews*.

The Syrian king, Antiochus, controlled ancient Palestine in the second century B.C.E., a time when the Jewish population was divided between pietist groups and factions of assimilated Hellenized Jews, many of whom were loyal to Antiochus. Antiochus decreed that Jews were prohibited from observing Shabbat, performing circumcision, and following all the other laws of Torah. Commanding Jews to worship only Greek idols, he sacked the Temple in Jerusalem and ordered death for any who defied his orders. While many pious Jews chose martyrdom rather than betray their God and their faith, one group of devout Jews fought back against Antiochus's armies. Mattathias and his five sons, one of whom was Judah the Maccabee, were from a family of Hasmonean priests in a small farming town called Modin. In 165 B.C.E. a small band of Jews led by Judah the Maccabee, no match in numbers for Antiochus's army, mounted a rebellion, even fighting on the Sabbath to defend themselves from total annihilation.

Reconquering Jerusalem on the twenty-fifth day of Kislev, the Maccabees cleansed the desecrated Temple, removed the pagan statue of Zeus, and replaced the altar upon which unclean sacrifices had been made. They rededicated the Temple by kindling its restored seven-branched menorah with the small amount of undefiled oil that still remained. As the story is told, this single day's quantity of oil miraculously burned for the eight days of the Festival of Dedication—*Hanukkah*, in Hebrew—that the Maccabees instituted.

The dramatic relighting of the Temple menorah is the religious event that established the origin of the singular ritual of Hanukkah. Since then, Jews throughout

the world have kindled the eight lights of Hanukkah in home and synagogue to reenact the Temple rededication in praise of God.

At the time of the Maccabees, Jews celebrated the miracle with a focus on the military victory. By the second century C.E., however, Talmudic rabbis had come to emphasize the miracle of the oil as the religious and spiritual basis for the holiday: "The Hasmoneans prevailed and won a victory over them, they searched and found only one cruse [of oil] with the seal of the high priest that was not defiled. It had only [enough oil] to burn for one day. A miracle happened, and there was light from it for eight days. In the following year, they established eight festival days" (Megillat Taanit 9).

The rabbis were so zealous in their interpretation of the miracle that they chose as the haftorah portion of the first Shabbat of Hanukkah a biblical passage that affirms, "Not by might and not by power, but by My spirit, says the Lord of hosts" (Zechariah II:14–IV:7; see the essay on the Cervera Bible, p. 20). They emphasized that the redemptive miracle was brought about not by the military power of the Maccabees but by God's own spirit and power.

Throughout Jewish history, Jews have interpreted the miracle of Hanukkah to reflect their own circumstances. In the fifteenth-century Hamburg Miscellany (page 35), the numerous depictions of Jews' defiance of oppressive leaders (such as the martyrdom of Hannah and her sons) gave heightened meaning to the suffering of Jews under the German persecutions of the previous century.

In the early twentieth century, the modern Zionist struggle saw in Hanukkah the historic idealization of its purpose and mission. Theodor Herzl proclaimed, "I believe that a wondrous generation of Jews will spring into existence, the Maccabees will rise again." A 1919 photograph of a tableau at a Poale Zion Chasidim pageant in Milwaukee, Wisconsin, (page 15) documents a costumed Golda Meir, later to become prime minister of Israel, holding a lit Hanukkah menorah, symbolizing Zionist hopes for the political rebirth of the Jewish state.

THE ART OF HANUKKAH

The art of Hanukkah has enriched the festival's celebration, adding to the joy of triumph, the spirit of sanctity, and the dignity of ritual practice. Treasured Hanukkah art objects are created for function or decoration, or as pure artistic expression. Crafted with an artist's unique design aesthetic, carefully chosen symbolism, skillful workmanship, and choice materials, these vessels of spiritual memory and contemporary experience heighten and deepen Jews' personal and communal connection to the meaning of Hanukkah.

Evolving in parallel with the customs of the holiday, the art objects associated with Hanukkah are an illuminating microcosm of the long history of Jewish art. With widely divergent styles and a variety of symbols and themes, these objects mirror the historical experiences of Jewish communities as they spread from ancient Israel throughout the diaspora. Rare archaeological artifacts hint at the holiday's observance in early Israel. The world's collective treasury of beautifully illuminated Hebrew manuscripts in libraries and museums are among the finest Jewish art objects ever created. The infinitely inventive ceremonial art form of the Hanukkah lamp reflects how Jews retained their customs and ceremonies while adapting to the different cultural environments in which they lived. In modern times, paintings, sculptures, graphics, and photographs, depicting scenes of warm home celebrations or illustrating historical events, have become important as a way to preserve memory, custom, and belief through the prism of the visual artist.

The creation of beautiful objects to enhance religious ritual is one way in which the Jewish people have expressed their intense love of God and their urge to glorify Him, and to this end Jewish sages encouraged artistic design, decoration, and the use of beautiful materials in the making of ceremonial objects. Basing this concept, called *hiddur mitzvah* ("beautification of the commandment"), on the biblical verse "This is my God, and I will glorify Him" (Exodus 15:2), the Talmudic rabbis urged Jews to make "a beautiful sukkah, a beautiful lulav, a beautiful shofar, beautiful fringe for your garments, and a

beautiful Scroll of the Law, and bind it with beautiful wrappings" (Babylonian Talmud, Shabbat 133b). Nearly two thousand years later, in a nineteenth-century popular code of Jewish law, this same attitude toward the making of beautiful ceremonial objects still prevailed: "One should use a beautiful metal menorah. If it is within one's means, he should purchase a silver candelabra to show deference for the precept" (S. Ganzfried, Kitzur Shulhan Arukh). The rabbis understood that the human gift of and need for artistic expression could be used to enhance spiritual acts of ritual and worship. Sacred music, the poetry of Jewish liturgy, and the architecture of synagogue design equally attest to the value and power of art in the service of the Jewish religion.

THE HANUKKAH LAMP

Many of the artworks related to Hanukkah that exist today are Hanukkah lamps, also called menorahs or Hanukkiot. Every Jewish home had a Hanukkah lamp, and often a household had more than one so that each family member could light his or her own. By the early twentieth century, museums and private collectors throughout the world had amassed significant collections of Hanukkah lamps. Because of this plenitude, as well as the richness of their style and iconography, Hanukkah lamps have been an abundant resource for information about Jewish life, thought, and practice throughout history.

A second-century Talmudic debate is evidence of the era's already widespread custom of lighting the Hanukkah lights at home. The rabbinic schools of Hillel and Shammai debated whether one should begin the ritual by lighting one light and increasing the number on each subsequent night or by lighting all eight lights the first night and decreasing the number every night thereafter. Hillel's position took hold based on the reasoning that holiness should always increase.

No objects have been found from ancient times that can be unequivocally identified as Hanukkah lamps. However, scholars are certain that they did exist. The

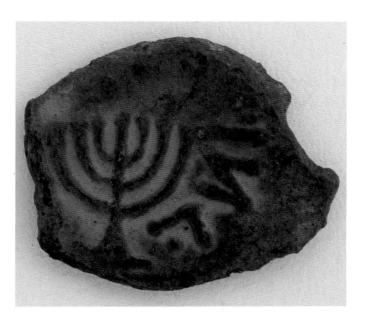

Coin from the reign of Mattathias Antigonus. Bronze. 40–37 B.C.E. Diam. 5/8 in. (1.6 cm). Israel Department of Antiquities Collection, The Israel Museum, Jerusalem.

Talmud describes a simple clay oil lamp that was in common use throughout the ancient Near East in the Roman era. For the celebration of Hanukkah, one of these lamps would have been used for the first night's lighting, a second such oil lamp added on the second night, a third on the next night, and so on until the eighth night. Because lamps made of clay became ritually unclean after only minimal use, Jews later created bronze versions in the form of the earlier Roman or Byzantine clay lamps.

The fifth- or sixth-century lamp depicted on page 13 is a unique and eloquent example. On it are portrayed the lulav, the etrog, and the seven-branched menorah described in the Bible; associated with Jewish religious practices in the time of the Temple, after the Temple's destruction these became messianic symbols, imbued with the hope of hastening the arrival of the messianic age, when the Temple would be rebuilt. Because the Talmud forbade the re-creation of the seven-branched Temple menorah after the Temple's destruction in 70 C.E., the menorah became the most prominent and widely used Jewish symbol. As such, it has appeared in murals, mosaics, architecture, decorative arts, and books throughout the centuries.

The oldest known image of the Temple's seven-branched menorah is on a coin from the reign of

Mattathias Antigonus (40–37 B.C.E.) (page 11). The menorah on the coin was designed at a time when the actual menorah of the Second Temple still existed. It therefore suggests what the biblical menorah, which Judah the Maccabee and his followers restored and lit at the rededication of the Temple more than a hundred years earlier, may have looked like. The menorah's image on this first-century B.C.E. coin carried not only a religious meaning but also—and more important—a political message against Imperial Rome.

Ironically, the artistic form of the Hanukkah lamp has rarely been based on the shape of the biblical menorah. While the biblical menorah's form was fixed by the Bible's description, which acted as a blueprint for its creation, the artistic style of the Hanukkah lamp is not fixed or rooted in prescription; rather, throughout the centuries it has adapted to the diverse artistic environments in which it was created. Hanukkah lamps not only are influenced by national or period styles but also dramatically and purposely imitate architectural styles as well. Hanukkiot, like all other types of Jewish ceremonial art, reflect the period and place of their origin in a brilliant amalgam with Jewish content, demonstrating a symbiosis between Jewish and other cultures that also has analogies in Jewish literature, music, and architecture.

The changes in form that have characterized the Hanukkah lamp over time signal the freedom Jewish artists have had to adapt and reinterpret the object's shape. No accounts, halakic dicta, or rabbinic codes or commentaries exist that prescribe or delimit the shape, style, or material of the lamp. Although these Jewish texts provide many instructions for the holiday's various ritual elements, such as the placement of the lamp in a doorway or near a window, the time of lighting, the order of kindling, or which oil is best, none of this literature concerns itself specifically with the artistic or formal qualities of the lamp. Thus human creativity has been free to develop a multitude of unique and inventive forms, a practice that continues in today's renaissance of artist-made Hanukkah lamps.

In direct contrast to the multiplicity of Hanukkah lamp types that have emerged over the centuries, the symbolic image of the seven-branched menorah has remained fixed over the last two thousand years. Its effectiveness as a symbol conveying its powerful messianic message is based on its exact representation of the Temple menorah as it is precisely described in the Bible (Exodus 25). The similarity of the images of the menorah found on the first-century Arch of Titus in Rome, in medieval illuminations such as the Cervera Bible (page 21), and in Ben Shahn's 1961 painting (page 87) stem from this biblical description. The candelabra type of Hanukkah lamp, exemplified by the Boller lamp (page 41), does reflect the influence of this fixed menorah image at the same time as it confirms the responsiveness of the lamp's form and style to artistic diversity.

Several requirements did pertain to the Hanukkah lamp, of course. It had to have places for eight separate lights, and they had to be in an even row. The rabbis also taught that the eight lights must be lit for the sole purpose of proclaiming the miracle and that no other benefit, such as illumination of work or play, can be derived from the light of the menorah. Thus the custom of adding a shammash (service light) to the eight lights developed to ensure the purity of purpose of the ritual lights. But the way in which the sole formal requirement of eight lights has been a constant amid the dynamic interaction of artistic vision and cultural influence is a powerful metaphor for the Jewish people's ability to retain their essential meaning and purpose while adapting to the various worlds in which they have lived.

This dynamic is clearly demonstrated in the important class of Hanukkah lamps whose form and decoration are based on architecture. Several lamps from fourteenth-century France and Italy, including the Lehman/Figdor lamp (page 25), imitate Romanesque and Gothic building styles with motifs such as quatrefoils, medieval mythic animals, a central rose window, and colonnades. This same principle can be seen in lamps from Spain and North Africa that reflect Moorish architectural elements such as the horseshoe arch or pointed mirhab-like niche (page 55) and in lamps that resemble the palace, civic, or church architecture of Renaissance Italy, such as the Palazzo lamp (page 31) or

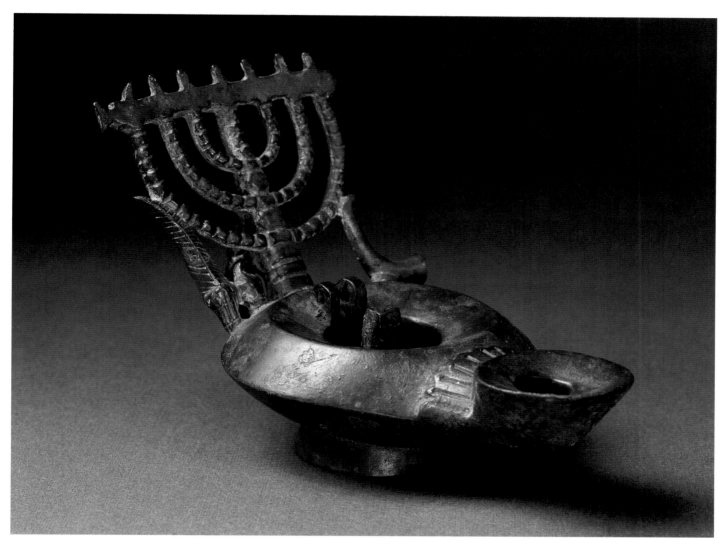

Oil lamp. Provenance unknown. Bronze. 5th or 6th century.
4 ⅜ x 6 ½ in. (11.1 x 16.5 cm). Schloessinger Collection.
Institute of Archaeology. The Hebrew University, Jerusalem.

the sixteenth-century Italian lamp based on the voluted dome of St. Peter's in Rome. The magnificent Brody lamp (page 51) is a baroque masterpiece consistent with the surface energy and monumentality of scale found in interior church architecture of the day.

Why is this architectural metaphor so pronounced and prevalent in the art of the Hanukkah lamp throughout so many centuries? The architecture, painting, sculpture, and decorative arts of any one era share artistic values and motifs. Hence both monumental architecture and diminutive decorative arts—including Hanukkah lamps—would have been crafted by artists who themselves were influenced by the spiritual and aesthetic value

system of an era. Moreover, the skilled goldsmith or silversmith in whose workshop a Hanukkiah was made would have utilized a basic stylistic vocabulary and repertoire of forms shared by many artisans of that time and place.

More significant, however, in understanding why architecture is such a prominent feature in Hanukkah lamps is the metaphoric link to the ancient Temple in Jerusalem, the rededication of which is the ritual basis for the holiday's observance. In a profound and intellectually elegant solution to the eternal problem of integrating artistic form and symbolic content, the Hirsch lamp (page 61) illustrates a clear relationship with an

13

imagined Temple in Jerusalem. A lamp such as this, architectural in form, becomes the embodiment of the Temple, and the act of lighting it may provoke a deep psychological connection to the original miracle of light that took place during the Temple's rededication.

Using architectural forms and motifs to signify the ancient Temple was a well-established tradition in Jewish art. For centuries the image of the Temple facade or that of the Ark of the Law functioned as a powerful messianic symbol, much like the motif of the seven-branched menorah. In fact, the menorah and architecture have been virtually interchangeable representations throughout the history of Jewish objects, one or the other symbolizing the Temple in Jerusalem as a harbinger to hasten the coming of the Messiah. Images of colonnades or building facades with columns supporting triangular pediments have been found on Roman- and Byzantine-era oil lamps, coins of the second-century Bar Kokhba revolt, the third-century murals of the Dura Europus Synagogue in Syria, and the mosaic floors of third- through sixth-century synagogues in Israel.

Interestingly, it is not the ancient architecture of the Temple that most often characterizes the Hanukkah lamps of later periods. Artists' inspiration came not so much from how they imagined the ancient Temple to have looked as from the architecture of important religious buildings of their own period and environs. Both the artist and the lamp's owner would have easily understood the reference to the Temple presented by the image of important Gothic, Renaissance, or baroque churches and synagogues. The Brody lamp (page 51) with its soaring baroque architectonic forms and the Hirsch lamp (page 61) with its neoclassical design clearly dramatize this principle.

In the Middle Ages, a Hanukkah lamp was developed with a metal backplate that enabled it to be hung upon a wall, as prescribed in the Talmud: "It is a religious precept to place the Hanukkah lamp by the door which is near the public domain, in such a manner that the mezuzah should be on the right hand and the Hanukkah lamp on the left." The existence of the back panel is not only structural; it also provides an opportu-

nity for decoration, encouraged by the rabbinic emphasis on *hiddur mitzvah* in the making of ceremonial art. The rare and elegantly designed Lehman/Figdor lamp (page 25) exemplifies a medieval back-panel lamp adorned with highly sophisticated artwork.

The Middle Ages also saw the development of bench-type Hanukkah lamps, so called because their construction made it possible for the lamps to stand on their own, sitting directly on a surface or being supported on small legs, instead of hanging. The Italian lamps on pages 31 and 33 and the German lamp on page 37 are early examples of bench-type menorahs that could be either hung or placed on a table. The great twelfth-century theologian Maimonides wrote, "In times of peril, one may place the Hanukkah lamp inside the house—it is even enough to place it on the table" (Mishneh Torah, Laws of the Megillah and Hanukkah).

Both the hanging type of lamp and the bench type have persisted for many generations throughout Europe, North Africa, and the Middle East. From Europe in the eighteenth and nineteenth centuries, examples include pewter lamps from Germany (page 43), brass lamps from Holland (page 49), or "synagogue-style" lamps from Poland (page 53). Bench and hanging lamps from North Africa and the Middle East are stylistically related to some of the European examples, as artistic influences often traversed the Mediterranean Sea. While lamps from this part of the world were also made to be hung, with metal back panels that became fields for artistic design, what was clearly different was their style, expressive of the dominant artistic and architectural traditions of the Islamic countries in which the Jews who made and used them lived. The metal backs are often fashioned in a cutout tracery technique. They are characterized as well by a continuous curving line, called an arabesque. Also typical of the repertoire of decorative forms on these lamps are abstract floral and animal patterns, architectural features such as colonnades, windows, and domes, and religious symbolism and inscriptions. Many of these lamps (see pages 55 and 73) are simultaneously bench type and hanging type.

The Middle Ages also saw the development of large

standing menorahs for the synagogue, serving travelers who would not have the opportunity to kindle the Hanukkah lights at home. There is evidence of such synagogue menorahs both in written material and in medieval manuscript illumination. The fifteenth-century Florentine *mahzor* (prayerbook for the festivals of the year) in the Rothschild Miscellany (page 27) depicts a large standing Hanukkah lamp with a man lighting it. Although three-dimensional imitations of the Temple's seven-branched menorah (pages 21 and 23) were forbidden, nothing prevented the design of a lamp in the Temple menorah's shape as long as an eighth light for celebrating Hanukkah was added. By the eighteenth century in Europe, this menorah-shaped Hanukkah lamp became popular in a smaller version for the home (pages 41, 57, 63, and 81). Increasingly used in the nineteenth and twentieth centuries, this form was often made for candles instead of oil and wicks.

Modern ceremonial artists create Hanukkah lamps with a contemporary artistic sensibility so as to enhance not only the beauty *(hiddur mitzvah)* of the ritual but also its meaning and relevance for today. These artists have produced exciting and unusual Hanukkah lamps in newly invented forms, using a wide range of nontraditional materials and technologies. Their work reflects modern art's openness to experimentation, radical change, pure formal abstraction, new symbolism, and postmodern juxtapositions of style. In many ways, however, their work parallels the long artistic tradition that preceded it. For both premodern and modern artists, the purpose was not only to make an object with which to perform the ritual but also to make the object beautiful in accordance with *hiddur mitzvah.* Today's artists incorporate motifs, symbols, and words that bring enhanced meaning to the pure functionality and beauty of the object while maintaining the most fundamental and defining characteristics of the Hanukkah lamp—having a place for eight lights and a shammash, although some have discarded an early rabbinic requirement that all lights be in an even row.

Throughout the centuries, both Jews and non-Jews have been the creators of Hanukkah lamps. Historically in some European countries, Jews were disallowed entry

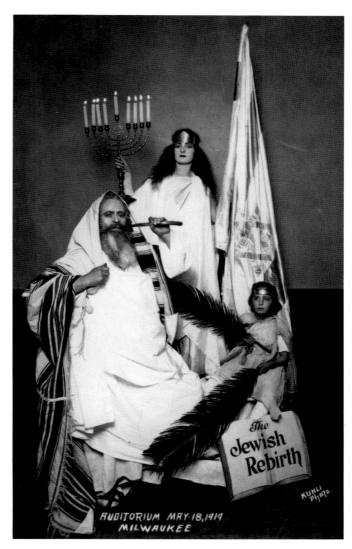

Photograph of tableau, Milwaukee, Wisconsin. 1919. Poale Zion Chasidim pageant, with Golda Meir holding the Hanukkah menorah. State Historical Society of Wisconsin.

into guilds whose members monopolized the production of decorative arts, while in other countries, especially in the Middle East and Eastern Europe, Jews were the exclusive metalwork artisans and the makers of Jewish ceremonial art. Throughout history Jews who had the means to do so commissioned liturgical and ritual objects from important Jewish and non-Jewish artists to satisfy the requirement that objects be beautiful and sophisticated, in adherence to *hiddur mitzvah.* Similarly today, individuals, collectors, and museums select highly creative and skillful Jewish and non-Jewish artists to design Hanukkah lamps (and other ritual objects) evocative of the modern Jewish and artistic spirit.

15

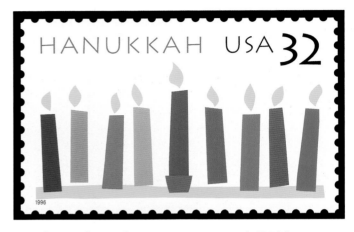

Hannah Smotrich. United States postage stamp from the "Holiday Celebration" series, 1996. Joint issue with Israel.

In the 1970s a renaissance in contemporary Jewish ritual art was born. Private collectors and museums began to commission new work from artists eager to explore their Judaism through art. At that time, the Skirball Museum in Los Angeles initiated a series of commissions of contemporary ceremonial art to enrich and revitalize its collections. The first commission was given to Otto Natzler, the internationally renowned ceramist, who created a Hanukkah lamp (page 91). In the pure geometry of its form and the elegance of its glazed surface, it is a uniquely modern piece. However, it stands firm in ancient tradition with a simple symbolic element—the Ionic capital form gently engraved on its surface, recalling the ancient Roman era in which Jews once lived. In another Skirball commission, sculptor Peter Shire created his first Hanukkah lamp (page 95). It was made of shapes of anodized and painted steel in a playful postmodern sculpture reflecting the joyful spirit of Hanukkah.

The Israel Museum in Jerusalem invited artists, designers, and architects from around the world, both Jewish and non-Jewish, to create work for a 1986 exhibition called "Contemporary Ideas for Light in Jewish Ritual." In response, the internationally known architect Richard Meier created a prototype for a Hanukkah lamp that dramatically used the history of architecture to symbolize the persecutions and triumphs of Jewish history (page 93).

In 1967, Moshe Zabari created a lamp innovative in shape and symbol and purposely traditional in its medium, silver (page 89). The lamp alludes to Masada, the mountain where Jews defied Roman oppressors for three years. Through his interpretation, Zabari has added Masada to the repertoire of Hanukkah symbols that celebrate martyrs and heroes such as Hannah and her sons and Judith, and he has created new thematic links to the significance of Hanukkah.

As recently as December 1995, the Jewish Museum of San Francisco invited 125 artists to create work for the exhibition "Light Interpretations: A Hanukkah Invitational." The result was a joyous multitude of new Hanukkah lamps with radically new artistic and icono-graphic interpretations. Kerry Feldman's cobalt blue glass candleholders (page 109), evoking the triumphant march of the Maccabean soldiers, or Ginny Ruffner's magical Aladdin's-lamp version of a Hanukkah lamp (page 101) locate today's ceremonial objects in both tradition and innovation.

FINE AND FOLK ART OF HANUKKAH

The art of Hanukkah includes ancient archaeological objects, decorative arts, exquisite illuminations in medieval Jewish manuscripts (pages 21, 23, and 27), modern book illustration, and fine arts (pages 87 and 109). As with the Hanukkah lamp, highly skilled artists embellished the liturgical texts of Hanukkah using the style of their time. Some depicted the ritual lighting itself next to the *al ha nissim* prayer thanking God for the miracle. Other painted illuminations depicted the Maccabees (medieval representations have them in armor) as well as other heroes and heroines symbolic of the defiance of faithful Jews against oppression. These include the heroine Judith, who slew Holofernes to save her people (page 27), and the martyred Hannah and her seven sons (page 35). In a modern effort to enrich Jews' understanding of and connection to the ritual, prayers, and meaning of the holiday, a series of profoundly spiritual works was painted by Leonard Baskin for a guidebook on the home celebration of Hanukkah published by the Central Conference of American Rabbis in 1989 (page 103).

Scenes of Hanukkah home celebrations were found in European engravings, woodcuts, books, and paintings from the eighteenth century on. The Age of Enlightenment encouraged the encyclopedic recording of knowledge. Within this context, many books attempted to record in word and illustration the customs and ceremonies of the Jews, along with those of other religious and national groups. One of the most renowned illustrators of such works was Bernard Picart, a non-Jewish artist whose famous series of etchings of Jewish observance and ritual for home and synagogue was a part of this phenomenon. With the emancipation of the Jews in the early nineteenth century throughout much of Europe, Jews began to participate in the general society in culturally new ways. Jews became artists and, to a certain degree, were accepted by society as a whole. Jewish artists of the caliber and reputation of Moritz Oppenheim, in Germany, created a series of genre paintings on Jewish life, including the wonderfully descriptive and informative *Kindling of the Hanukkah Lights* (page 65). In the late nineteenth century, K. Felsenhardt, in Poland, created another painted depiction of the celebration of Hanukkah similar in family warmth and cheer but vastly different in socioeconomic and religious circumstances (page 69).

In the twentieth century, folk artists such as Malcah Zeldis, who employs a "naive" painting style, evoke memories of contempory Hanukkah celebrations merging traditional elements with new cultural contexts; one of Zeldis's paintings (page 105) portrays her New York apartment with the Hanukkah lamp on the festival table proclaiming the miracle inside, while through the window the characteristic New York skyline can be glimpsed.

Artist and calligrapher Michel Schwartz uses color and letters exclusively in his calligraphic painting, to recall the historical triumph of the Jewish people over their adversaries. Beginning with the traditional blessings recited when lighting the menorah and concluding with the Hanukkah hymn "Ma'oz tzur" ("Rock of Ages"), this work is part of a resurgence of the Jewish book arts in the latter half of the twentieth century. The Hanukkah lamp and its lights, in conjunction with the

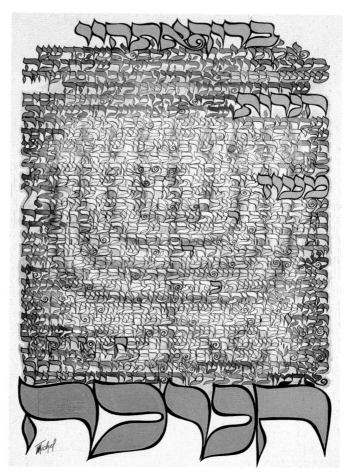

Michel Schwartz. The Joy of Hanukkah. *Calligraphic painting. Acrylic, dyes, pen and ink. 18 x 24 in. (45.7 x 61 cm). 1986. Collection of the artist.*

prayers and songs, convey the artists' strong religious and spiritual roots.

California ceramic artist Karen Koblitz transmits her own message of the meaning of Hanukkah in a contemporary colorful ceramic sculpture (page 111). In an exuberant still life that vividly represents a modern American Hanukkah, Koblitz creates a lively monument to the holiday, with colors and patterns evoking the joyful celebration. Contemporary artist Bill Aron has created a beautifully composed photograph akin to the genre tradition of the Oppenheim and Felsenhardt paintings, simply and directly capturing the dignity and value of the oldest traditions of Hanukkah (page 115). In the photograph, the kindling of the Hanukkah lights can be seen through the window, as prescribed by the rabbis. The lighting of a candelabra such as this one connects Jewish families of today to their ancestors, who cele-

brated the miracle by similarly kindling lights for eight nights. The heart of the image, however, is the importance of one generation's teaching the next about the ritual and meaning of the holiday. Without this deliberate transmission, neither Hanukkah nor Judaism itself would be alive today.

The dreidel is the traditional game piece of the festive holiday, for centuries adding to Hanukkah's fun and joyful atmosphere. Eighteenth- and nineteenth-century dreidels from Europe were made of wood, ivory, or metal; simple, unadorned examples have come down to us and are described in many a Jewish short story or poem, and more elaborate examples (carved, painted, or made with cast decorations) also exist (page 71). The late twentieth century has seen an efflorescence in the art of the dreidel (page 107). Some, in wood or plastic, are mass-produced in bright fluorescent colors or in versions that substitute Mickey Mouse for Judah the Maccabee. Others glow in the dark, while yet others are filled with confetti or colored liquid, or can be wound up. In Israel today, a number of immigrant Russian artists expert in painting miniatures have begun to decorate wooden dreidels with diminutive scenes. Throughout the world, contemporary artists have designed elegant, unique dreidels in a multitude of traditional and nontraditional materials; while these dreidels may be used in the customary game of chance, they are also artistic icons symbolizing both the triumph and the cheer of the holiday.

HANUKKAH'S VALUES AND VITALITY

The meaning of Hanukkah and its celebration continues to be relevant for all Jews. Its miracle reaffirms Jewish belief in God's redemptive power, its message underscores the right to individual freedoms, and its joyous home celebration provides the experience and memory of family strength that is so important to the continuation of Jewish life. Louis Brandeis, justice of the United States Supreme Court, was among many who understood the relevance of Hanukkah for all peoples: "As part of the eternal worldwide struggle for democracy, the struggle of the Maccabees is of eternal worldwide interest." Hanukkah celebrates not just the rights of Jews but also the rights of freedom for all people.

The United States inaugurated a new series of holiday celebration stamps in 1996 with the issuance of a stamp commemorating Hanukkah. A joint issue with Israel, the stamp, designed by Hannah Smotrich, features an image of a menorah with nine multicolored candles (page 16). On the occasion of the stamp's ceremonial unveiling, the U.S. postmaster general spoke of how the "traditions of Hanukkah hold special meaning for celebrants around the world and for millions of Americans. It's also a tale of universal appeal. [In] a story of triumph over adversity, strength in conviction, and belief in the possibility of miracles . . . [the candles] remind us, as Americans, that at the heart of our diversity we are joined together by many common needs and values."

The art of Hanukkah has played a critical role in the transmission of the holiday's message from one generation to the next. The lamp makes possible the vivid ritual reenactment of the ancient events celebrated by the festival, a reenactment that makes real to each new generation Hanukkah's religious and spiritual meaning. Artistic illustrations embellish prayers in manuscripts and printed books, enlarging their meaning to the reader. Paintings and sculptures evoke and preserve the collective memory, specialized customs, and joyful emotion of the holiday. These art objects are an integral part of Hanukkah. They have been vested with the power and purpose of Hanukkah in order to keep the light of life, hope, and redemption burning. Indeed, the continuing and ever-renewed vitality of the art of Hanukkah presents us with a hopeful sign that the lights of the Hanukkah lamp will always be kindled.

THE ART OF
HANUKKAH

CERVERA BIBLE

Joseph ha-Zarefeti (Joseph the Frenchman), artist

Cervera, Spain, 1300

The Cervera Bible is an important and beautifully conceived early Hebrew illuminated manuscript from the Castilian region of Spain. This painted full-page illumination depicts the artist's vision of the original seven-branched menorah that stood in the Wilderness Tabernacle—the movable sanctuary symbolizing God's presence amidst the early Israelites after the revelation at Sinai—described in Exodus. Because of this history, the menorah has always been a ubiquitous and sacred Jewish symbol. God gives precise design requirements for the lamp's construction in Exodus 25:31, accounting for its seven branches, its almond-shaped decorations, and its material, which is pure gold.

I Kings 7:49 describes King Solomon's Temple, including "the lampstands of pure gold." It was such a seven-branched menorah that the Maccabees restored when they rededicated the Second Temple in 165 B.C.E. Thus one of the most powerful symbols of Hanukkah is the seven-branched menorah, which was lit for eight days of celebration and now symbolizes the rededication of the Temple and the protection of Jewish religious rights.

This image is a precise interpretation of the vision of Zechariah, which is read as the haftorah on the first Sabbath of Hanukkah (Zechariah II:14–IV:7). Zechariah, who returned from Babylonian exile in 537 B.C.E., encouraged his fellow Jews to rebuild the Temple and restore the Jewish state. In a dream, the prophet saw a gold seven-branched candelabra flanked by two olive trees, which supplied oil through bowls and pipes to the menorah. An angel reveals the dream's meaning with the words "Not by might and not by power, but by My spirit," which alludes to God as the unseen power that fuels the menorah and makes possible both peace and the rebuilding of the Temple. The menorah is metaphorically a tree of life, and in this unique image its symbolic lights are fed by the two olive trees, which represent Joshua and Zerubbabel, the religious and civil leaders through whom God's power and presence will bring peace and grace in the form of the completed Temple.

This medieval rendering of the image together with the biblical words are a fitting commemorative of Hanukkah's yearly ritual celebration. Furthermore, it is a beautiful pictorial reflection of the Talmudic pronouncement in Shabbat 23a: "R. Joshua b. Levi said: All oils are fit for the Hanukkah lamp, but olive oil is best."

Parchment. 11 ⅛ x 8 ½ in. (28.2 x 21.7 cm). Ms. 72, fol. 316v. National Library, Lisbon.

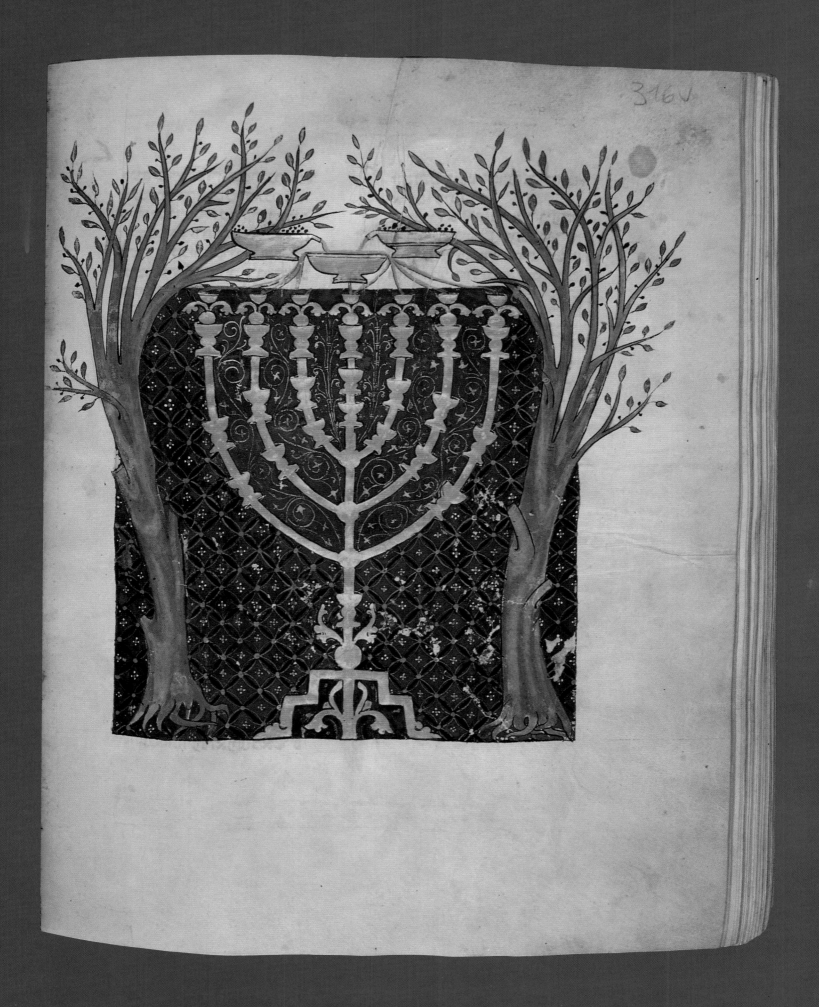

Aaron Pouring Oil into the Menorah
(from the British Museum Miscellany)

Artist unknown
Amiens, France, c. 1280

This is a thirteenth-century illumination of a passage from Exodus describing Aaron, the high priest, performing the rituals and rites of the Tent of Meeting. Exodus 27:20–21 states, "And thou shalt command the children of Israel, that they bring unto thee pure olive oil beaten for the light, to cause a lamp to burn continually. In the tent of meeting . . . Aaron and his sons shall set it in order to burn from evening to morning before the Lord; it shall be a statute for ever throughout their generations on the behalf of the children of Israel."

This is one of the earliest Hebrew manuscript illuminations of this scene. The Hebrew inscription reads, "This is the menorah and Aaron pouring oil into the lamps." This highly descriptive image illustrates the biblical passage and underscores the fact that from the time of the Sanctuary in the desert, the golden menorah with its eternal light was intended to be a symbol of and for the generations of Israel. The number of Jewish institutions today, both religious and cultural, that use the seven-branched menorah as a vibrant symbol of Judaism attests to the tenacity and power of its symbolism.

Later, a similar golden seven-branched menorah was among the significant ritual implements necessary for the holy service in both the First Temple, built in Jerusalem by Solomon, and in the Second Temple, built after the Jews returned from exile in Babylonia. "And Solomon made all the vessels that were in the house of the Lord: the golden altar, and the table whereupon the showbread was of gold; and the candlesticks, five on the right side, and five on the left, before the Sanctuary of pure gold" (I Kings 7:49–50).

It was this holy menorah that the Maccabees relit in jubilant triumph after they reclaimed the Temple from the Syrians who had devastated it and prohibited Jewish religious observance. Rabbinic literature claims that only enough undefiled oil was found to last one day, but miraculously it lasted for eight days. Thus on the twenty-fifth of Kislev was inaugurated the Festival of Lights, which henceforth was to be celebrated for eight days to commemorate the Jews' newly won right to practice their religion freely.

This elegant Gothic painting shows a large standing menorah. Such monumental lampstands were used in European synagogues so that travelers (who often found lodging in the synagogue) could participate in the ritual lighting of the Hanukkah lights. These lamps, however, always had eight branches for Hanukkah, with a shammash as a ninth, as the sculptural re-creation of the Temple's seven-branched menorah had been prohibited by the Talmud.

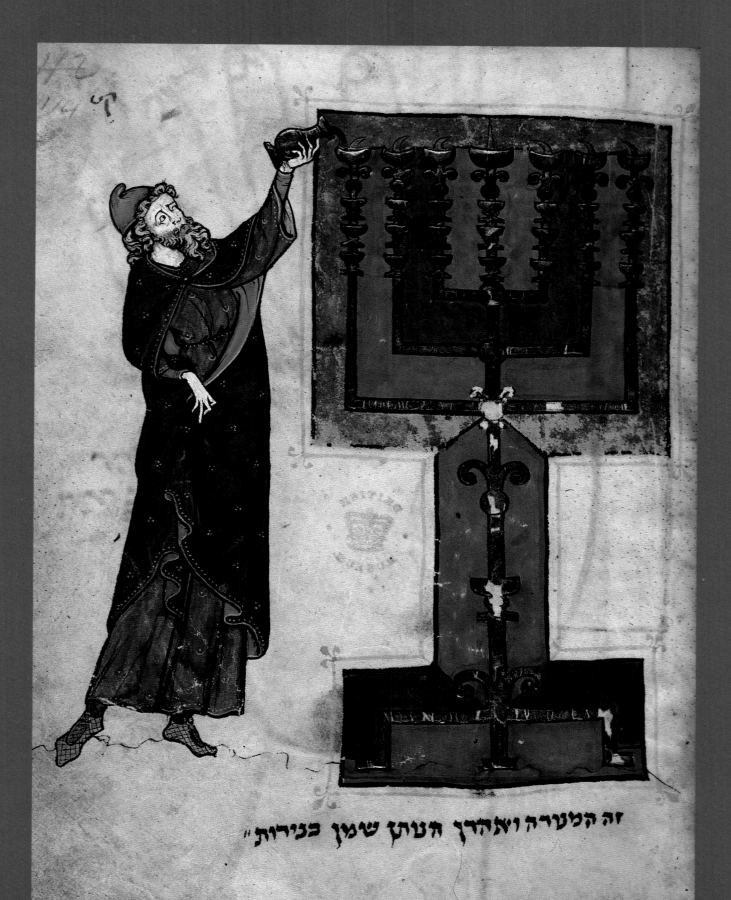

זה המנרה ואהרן הטיב שמן בנירות "

LEHMAN/FIGDOR LAMP

Artist unknown

Italy, 16th century

The architectural character of this rare cast bronze lamp is related to the High Gothic style of the European Middle Ages. The lamp's design is a synthesis of the structure and decoration typical of medieval churches. Hanukkah lamps such as this were designed with a back panel to facilitate the hanging of the ritual lamp in a window or inside a room so that it could be seen from outside the house, as prescribed by the Talmud. This structural necessity provided the opportunity for artists to invent shapes and add symbolic ornamentation. The architectural features that the maker of the Lehman/Figdor lamp adapted from Romanesque and Gothic styles include the triangular pediment, the intricate colonnade of intersecting arches (attributable to Sicilian influences), and the sculptural and bas relief embellishments. The four-pointed quatrefoil enclosing a mythical animal as well as the two roundels with beasts are irrefutably Gothic motifs. Art historian and scholar Bezalel Narkiss suggests that this lamp is the oldest Ashkenazi bronze lamp in existence.

The animal in the central medallion has been variously identified as a salamander, a dragon, or a phoenix, all of which are associated with fire and are thus symbolic of the ritual lighting of lights at Hanukkah. Lions of Judah inhabit the roundels in an artistic convention typical of medieval manuscripts. Sculptural squirrels flank the Hebrew inscription, which is placed in a band atop the woven arcade. The quote "For the commandment is a lamp, and the Torah is light" (Proverbs 6:23) has been aptly applied to Hanukkah for many hundreds of years because of its allusion to the physical presence of the Hanukkiah itself as well as its profound spiritual meaning. Judaica curator Cissy Grossman points out that the squirrels, which are holding nuts, are most likely a visual reference to a traditional Jewish metaphor linking the Torah to a nut. Just as one peels away a nut's hard outer shell to get to the desired kernel, so the study of Torah requires many levels of interpretation to discover its true meaning. This explanation for the squirrels complements the message of the quote from Proverbs, as both signify the glory of Torah.

The shammash is the large rectangular font to the left of the others. Because it is permanently attached to the eight other burners, it could not have been used to kindle the other lights. Rather, its purpose was to illuminate the activities that take place while the holy lights are burning. This is because rabbinic precepts forbid using the eight Hanukkah lights for the illumination of work or leisure activity.

Bronze. 5 3/8 x 6 11/16 x 2 in. (13.7 x 17 x 5.1 cm). Congregation Emanu-El of the City of New York.
Bequest of Judge Irving Lehman, 1945. Formerly in the collection of Dr. Albert Figdor, Vienna.

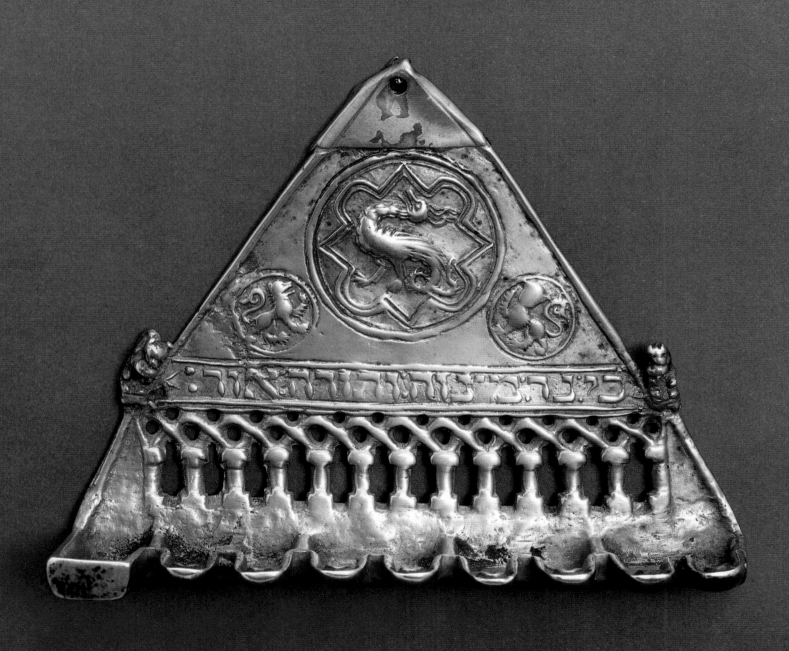

Judah the Maccabee and Judith and Holofernes
(from the Rothschild Miscellany)

Artist unknown
Northern Italy, c. 1450–80

The Rothschild Miscellany is one of the most elaborately illuminated Hebrew manuscripts in existence. It has over three hundred text illustrations and is written in an elegant square and cursive script in black ink and gold leaf on vellum. The German Ashkenazi name Moses ben Yekutiel ha-Kohen is noted in the book, and it is likely that he commissioned the volume and/or was its owner. An entire Jewish library in one volume, the Rothschild Miscellany is a compilation of nearly fifty religious and secular works, including books of prayer *(siddur)*, religious law, ethics, belles lettres, and liturgy, a Passover Haggadah, and a midrash. A work of exquisite artistry and painterly skill from the Florentine Renaissance, it is a rare example of a sumptuous volume made for a Jew of great wealth and taste.

The illustration on this page is from the Book of Josippon, which is a medieval Jewish book based on Josephus's ancient account of Jewish history. The symbolic images of Judah the Maccabee and Judith decorate a text page dedicated to the hymn of the Sabbath during Hanukkah. Judah the Maccabee, the Jewish military hero who in 165 B.C.E. reclaimed the Temple in Jerusalem, which had been taken over and defiled by the Syrians, is pictured as a medieval knight in a full suit of shining metal armor. He is shown triumphantly brandishing a sword high in his right hand and leaning on a shield adorned with a rampant lion, the Jewish and universal symbol of strength. Here, the biblical and medieval ideals of the hero are conflated in an image that symbolizes the promulgation of God's will with might, fortitude, faith, courage, and truth.

To the right of the image of Judah the Maccabee is an elegant painting of the popular biblical story of the heroine Judith, who decapitated Holofernes, the military leader of the enemy of the Jews. In a beautiful gold Renaissance-style tent, Judith, with her sword held aloft in her right hand and the head of Holofernes in her left, walks away from the bloody bed of the general after performing this courageous act, which saved the Jewish people from destruction.

Pen and ink, tempera, and gold leaf on vellum. 8 ¼ x 6 ¼ in. (21 x 15.9 cm). Ms. 180/51, fol. 217.
The Israel Museum, Jerusalem. Gift of James A. de Rothschild, London.

כי שלו עם המלך לכת לירושלם · ובמצור מהתעבבצור חדיר וסלח ובמעש נ'וספ'ן מ'חכמית וכ'סור מ'שום התג'' · וייח''
ויפ'תו וחד' לפ'ני הדל' · וי'אמר' א'ל' המלך' מה הדב'ת' מה ל' להגב'ת בב'ני · או ל'ומ'ר מ'ל'ב'מות'ע הב' יהננ עוב'ן יו'ן
יוהנ'ן לקב'ל הדמ'ות' על א' ועל ת'מ'ות'ע · ויק'ש'ן · הגולך · מ'חוב' · ויע' להב'ד'ל מ'ח'ב'ת נ'חט'וא · וי'ס'ימ' זו'ה'ת על הי'ל'ש' · וא'ח'ד'ר''
ומ'ות'

מ'כ'ב'י

כי אגב'ה והט'
והשוב אזנך
הטית שוע' ן
ל'קשוב · או'ני
אור'ב'הי · ב'ק'ש
מ'על'ש'יל'ה לב'י
לנ'שוב · אב'י'צ'ה
ואזפרה רמי · ן
ק'ד'ם · אש'ר · כ'
ק'ראוב'י · כ'ב'ך
פ'נ'ב'ת'ם · אור'ב' '
אור'ד'ת'ם · אגן

אג'ד'ה ול'א · אר'ם · אש'יח'ה · צ'רה · ונ'ק'מ'ת · אנ'ט'ור'ב'ס · אב'ה · ח'ס'יר'י · ומ'נ'ו
ומ'ש'יח'י · נ'ב'ם · אור'ל'י · עמ'י · פ'ה'ק'ר'יוב'י · ל'ה'ר'כ'ב'ס · יי · יב'/
וש'ן · וי'ע'ד · ס'ום'י · פ'ל'ה'ר'ות' · ב'מ'ד' · ר'כ'ב'ם' · ש'נ'ו'ס'י · ל'פ'יד'ות' · מ'וס'ב'ה · ל'ה/
ה'ר'א'ות' · ב'ת'וך · ע'יר · ב'ק'ב'ר'ות' · ק'ד'וש''

ב'או · אב'ן · פ'ר'יד'ב'ם · ל'ל'ש'ון · מ'ת'ח'ר'י · א'ת · ה'פ'ל'יד' · ל'ע'ש'ן · ב'ע'ר · ל'ה'ב'ר'ית · ש'ר'ו'צ'י · ז
ג'ש'ן · ב'ע'ר'ה · ח'ב'יה'ו · וי'ה'א · ב'פ'ת'ע · ב'יל'ה · ב'ס'ר'י · וח'ו'י'ה'י · ש'י'ת'ע · ב'יע'ר'ים
ח'ו'פ'א'ת'י · כ'ב'ה'ב'יה'ז · ל'ה'ה'ע · ב'ב'ל'ה'ת'ו · ל'ה'ש'מ'יד' · ע'ב' · ו'ל'ר'פ'וס · ב'ר'א'ר · ל'ש'ר · צ'ב'א'ו

Judith

Sandro Botticelli

Florence, Italy, c. 1469–1470

The Book of Judith, like 1 and 2 Maccabees, never entered the canon of the Hebrew Bible. Written between the second century B.C.E. and the first century C.E., it recounts the dramatic story of the piety and heroism of Judith, who saved her people through a miracle granted by God. Midrashic literature claims Judith to be a member of the Maccabee family, and since medieval times this book of the Apocrypha has been associated with Hanukkah. Judith was a pious Jewess who lived at a time when an Assyrian general, Holofernes, was besieging her town, Bethulia. Claiming that "God will look with favor on Israel, by my hand," Judith entered the camp, decapitated Holofernes in his tent, and returned with his head. The Assyrians fled at the discovery of Holofernes's death. "And . . . the children of Israel . . . came to behold the good deeds which God had wrought for Israel and to see Judith and to hail her" (Judith 15:5).

Sandro Botticelli, one of the greatest painters of the Florentine Renaissance, painted two small works in the 1470s illustrating the story of Judith and Holofernes. In the first panel, he depicts the horrific moment when Holofernes's aides discover his bloody, decapitated body in the tent. In the second panel (pictured), Judith and her maidservant seem to elegantly float or dance home at dawn across the landscape, sword and gruesome head in tow. The ethereal look upon Judith's face and the transparent qualities of her weightless body and drapery reflect the transcendent and redemptive act she has just performed. Piero Medici, Botticelli's patron, encouraged the artist to choose subjects of classical, mythological, and biblical origin that would also signify the virtues and triumphs of Florence. Just as Jews saw God's miraculous saving power in the story of Judith's triumph and heroism, so too did the theme provide the Italian Renaissance with a profound metaphor for the power and rectitude of the Florentine state and its leaders.

Tempera on panel. 12 ½ x 9 ½ in. (31 x 24 cm). Uffizi Gallery, Florence, Italy.

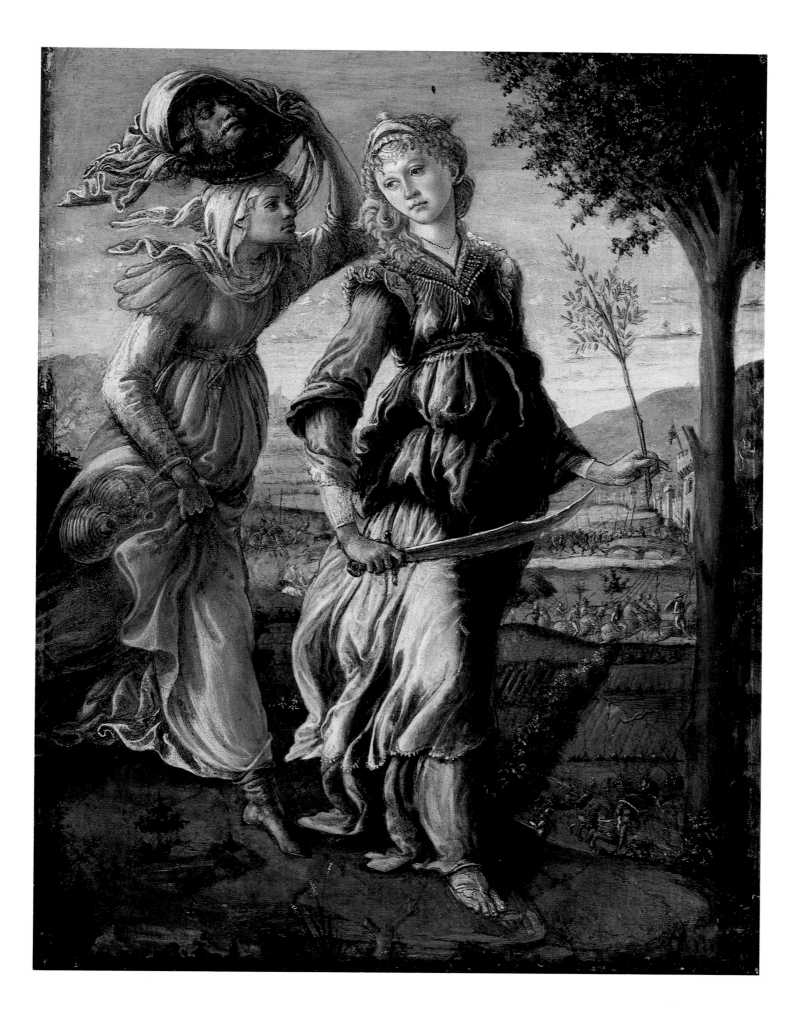

PALAZZO LAMP

Artist unknown

Italy, 16th century

Italian Renaissance art incorporated into its repertoire pagan and mythological motifs found in ancient classical art. Jewish art of the same period also borrowed visual images from the same sources. Italian brass lamps of the sixteenth and seventeenth centuries abound with classical and Renaissance motifs, such as angels, masks, mermaids, cherubs, beasts, tendrils, amphoras, medallions, flower baskets, cartouches, and other mythological symbols. The overall shapes of the back panels of such Italian lamps, whether solid or open fretwork, refer to a variety of architectural and furniture styles typical of the era.

The composition and decorative program of this Hanukkah lamp derive from fifteenth- and sixteenth-century bronze boxes made as containers for jewelry or writing implements. The Medusa in the center medallion and the flanking images of centaurs with nude females astride their backs are borrowed from ancient Roman sarcophagi and classical art motifs. The centaurs hold cornucopias, which form a medallion around Medusa's head, and Pan's flute and a zither lie on the

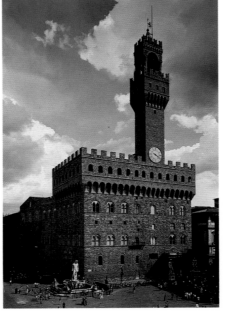

ground. Family coats of arms, typical of the Italian Jewish community, adorn the side panels of the lamp. The eight oil burners protrude from the relief back panel. The shammash, or servant light, is missing. A nearly identical lamp in the Cluny Museum in Paris has the shammash attached to the upper right corner of the back, indicating where it might have been originally affixed on this lamp.

In an early example of the relationship between architecture and the Hanukkah lamp, the serrated border along the top of the lamp is an imitation of the crenellations that appear as defense elements or decorations on city walls and castles, seen here in the Palazzo della Signoria in Florence. Such towers appear in other sixteenth-century Italian lamps, reinforcing the architectural antecedents of this lamp's design. As early as the fourteenth century, an Italian Jewish manuscript illustrates both a Hanukkah lamp with a similar crenellated top and a man in early Renaissance dress lighting the oil cups for the festival's ritual.

Above: *Palazzo della Signoria. Arnolfo da Cambio, architect. Florence, Italy. 1302.*
Right: *Bronze, cast. 4 ³⁄₈ x 8 ¹⁄₈ x 2 ¹⁄₄ in. (110 x 205 x 55 cm). Stieglitz Collection, 118/855. The Israel Museum, Jerusalem.*

RENAISSANCE LAMP

Workshop of Joseph de Levis (?)
Italy, late 16th or early 17th century

This rare and elaborate Hanukkiah and a similar one in the collection of Congregation Emanu-El in New York were probably made from the same mold. Small bronze decorative art objects were popular in the Renaissance, and among those made exclusively for Jewish use were lamps with the distinctively Jewish feature of containers for eight lights.

A scene illustrating a dramatic moment in the story of Judith and Holofernes is the focus of the bronze relief back panel of the lamp. Having just decapitated Holofernes, Judith holds the knife with her right hand as her left is about to drop his head into a sack held open by her kneeling maidservant. The fabric of Holofernes's tent is draped above Judith's head, and his bed linens fall in disheveled swirls, reflecting a similar composition in one of Botticelli's two paintings of the subject.

This event is rendered in a fully dramatic and detailed scene just as it is described in the book of Judith from the postbiblical writings of the Apocrypha. More frequently found in later lamps from Italy and Germany is Judith as a single iconic figure. Since the Middle Ages,

Jews had associated Judith with the courage and triumph of the Maccabean heroes of the Hanukkah story. The Italians of the Renaissance also idealized Judith as a figure emblematic of both justice and virtue. The statue at the top of the lamp, which may represent a Hasmonean priest of the lineage of Judah the Maccabee, may have been attached at a later time.

The style of this lamp is typical of the Renaissance. Characteristic artistic motifs include masks of both putti and bearded men, scrolls, angels, and family coats of arms. The two flanking figures near the top of the lamp are a clear reference to similar reclining statues by Michelangelo in the Medici Chapel. Scholars propose that the Joseph de Levis family workshop, which may have produced this lamp, was Jewish, which would confirm the existence of Jewish artists working in Italy during the Renaissance. The artist of this lamp was a particularly skilled metalsmith and sculptor whose innovative artistry enabled him to create one of the supreme aesthetic expressions of Jewish art for his own time as well as for centuries to come.

Bronze, cast. 10 ½ x 10 ⅜ x 2 ½ in. (27 x 26.5 x 6.5 cm). The Sir Isaac and Lady Wolfson Museum, Hechal Shlomo, Jerusalem.

Hannah and Her Seven Sons
(from the Hamburg Miscellany)

Artist unknown

Hamburg, Germany, second quarter of the 15th century

The Hamburg Miscellany is a compendium, incorporating a prayer book for home and synagogue use, a Haggadah for Passover, lamentations, and prayers for life-cycle ceremonies. It also contains a series of unique illustrations for the *piyyutim* (poems) for Hanukkah. These detailed, graphic scenes of martyrdom rarely have been depicted in similar manuscript treatments of the same text.

All the images of martyrdom chosen to illuminate the Hanukkah passage are postbiblical and come from the Apocrypha. The miniature at the top of the page illustrates the story of Hannah and her seven sons, as told in 2 Maccabees. Hannah, with arms upraised in profound grief, kneels over her fallen sons. Antiochus murdered them in front of her because they refused his commands to bow down to him and to eat food forbidden by Judaism. Hannah is valued in Jewish history as a woman who instilled piety and faith in God in her sons, encouraging them to sacrifice themselves by assuring them that the evil king would receive just punishment at the hand of almighty God.

The source for the scene in the lower painting is a legend that recounts how Antiochus forbade Jewish women from using the mikvah (ritual bath). In this bed-room scene, a husband lies under the covers, waiting for his wife, who is immersed in the water of a mikvah that the midrash claims was sent by God so that the laws of purity could be observed. Both of these scenes depict the resistance to evil rule by Jews faithful to God and Torah. Each image reinforces the understanding of defiance, heroism, faith, and redemption that is the ultimate message of Hanukkah. The choice of these and the other midrashic tales of defiance recounted here also have an added meaning, as they recall the persecutions, riots, and massacres suffered by the Jews in fourteenth-century Germany, a number of years prior to the creation of this manuscript.

Although the naked female form found here is unusual for the time, the bold use of the human figure was a common practice in the art of the Hebrew manuscript in Spain, France, and Italy, as well as in the northern countries. The Second Commandment prohibited the making of a human likeness for the purpose of idol worship. This was clearly understood by these medieval artists, and the Jews who commissioned and used these books were comfortable with the use of the human form in illustrations.

Vellum. 11 ⅞ x 9 in. (30 x 22 cm). Cod. Heb. 37 fol. 79v. Staats-und Universitätsbibliothek, Hamburg.

הראשון בתה נבח וער ראשו חשׁוּ בתותה
זמזב להרוג שׁשׁת אבוד זד יהיר בעברות טרחבי ים
זהב ככבש אלהה פיוהדרי זמם אפתה השביעי קה
קטנב זהב אשרד אלי נב זיבגצתר לי לבישׁה ם
קונב זורז העלב הטוב לבחר
וצה הדגבי לביה תאחרי זגה
וצהתי להשתברות לא אחר
רבוודהר מושׁל רשׁע הי
חיוק ביבותהן בלי פטע חסו
הלדי ולכבלב שׁיעשׁע הזתה
הורותב משׁפטי בגיה הבצה
נפשׁה על נינה הלפה והשׁב
רדהה לקוגיה הבסי אבבר
לעבוד הסירב אילו והריגתב

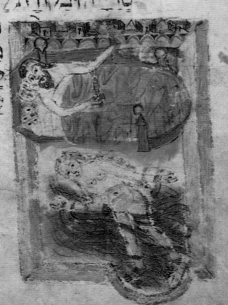

זבודי חנוז כרוגי בלתר וכורי טפס עדבריוז
מדה טיפטופי אשר לא יבדה טימוסי יחונ החרי
קראז טיבס זכר שׁבזי יהורי טבוח וקריז כברי גרי
טרייה ובקרות להבויד בשׁליי יוהר טבילות בזנב
מגשרתב הודיי ל אטו קיישׁרים מבנב
מבגשׁיתב להבדיל טרדם סקידתנב
להדרי יהיד ונישׁא שׁתב
שׁע ד יפד לברלם מקנאות ביב

HEILPERIN LAMP

Artist unknown
Germany, 1573–1574

This early Hanukkah lamp from Germany is unusual because its date is incorporated into the piece itself. The Hebrew inscription refers to (5)334, which translates into the year 1573 or 1574. The inscription also mentions the name Meir Heilperin, who might be either the lamp's maker or the person who commissioned it.

The artist used bold formal elements and complex symbols as metaphors for the rituals of the holiday. The simple wide expanse of the metal back panel eloquently displays as decoration the calligraphed wording of some of the prayer liturgy of Hanukkah. The Ashkenazi square script is carefully and elegantly rendered in a style similar to that found in German Jewish manuscripts of the High Middle Ages. The design and placement of the letters express a dignity and vitality much like the triumphant spirit of the festival itself, particularly as evoked by the inscription, which is a blessing recited after the kindling of the lights: "These lights we kindle to commemorate the miracles, the wonders, the redemption and the victorious wars You wrought for our forefathers in those remote days and at this time, through Your holy priests. And all through the eight days of Hanukkah these lights are holy, and we have no permission to use them, only to behold them, to thank Your great Name for Your miracles and wonders and redemption."

The simple elegance of the form of the dragon heads (which metamorphose into volutes) is a direct influence from a convention typical of Hebrew and other illuminated books. In these books, playful fantasies of line and image decorate letters, words, and entire pages. Together the text and animal imagery embodied in this metal Hanukkah lamp work to enhance each other's message in a synthesis common in the Jewish arts.

Another important symbolic tradition reflected in this lamp is architectural references. The side panels are fashioned as turrets or towers, a defensive or decorative feature commonly found in castles and city walls in Europe. Such pierced and cutout towers with windows have many antecedents in German architecture. Related lamps from sixteenth-century Italy and eighteenth-century France, which also have the Hanukkah liturgy proudly emblazoned in metal on their back panels, are also in architectural shapes that derive from the architecture of those countries.

Bronze, cast, engraved. 9 1/8 x 13 1/2 x 4 in. (23.2 x 34.3 x 10.2 cm). The Israel Museum, Jerusalem.

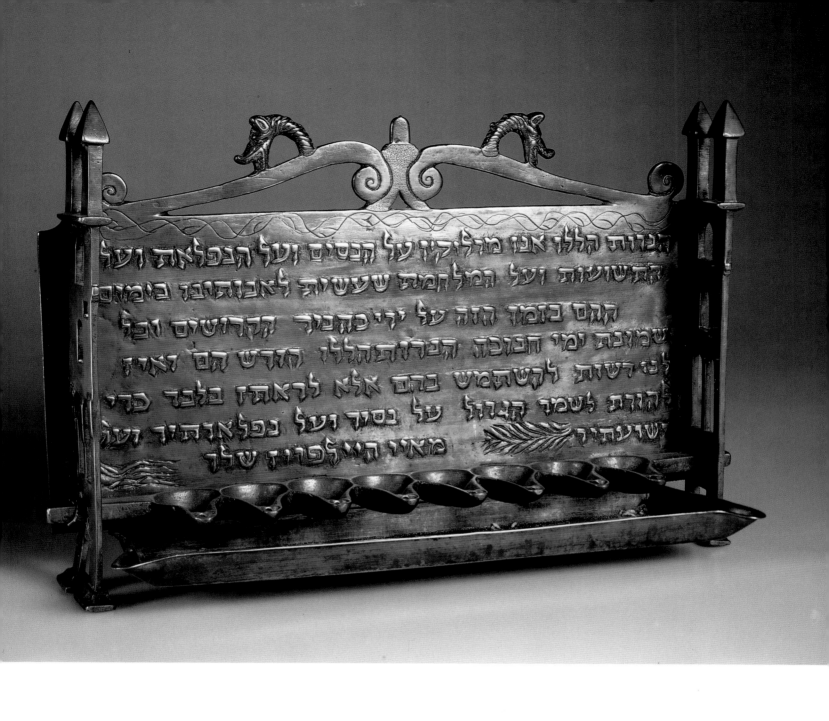

STAR HANGING LAMP FOR THE SABBATH AND FESTIVALS

Workshop of Johann Valentin Schuler

Frankfurt am Main, Germany, c. 1680–1720

In the Middle Ages in Europe, star-shaped hanging lamps were used for home illumination by both Jews and non-Jews. Jews also made use of such lamps for the ritual lighting of lights and blessings that consecrate each of the annual Jewish festivals and the Sabbath. Prayers over lights are said every Friday evening to welcome the Sabbath, and they are also said every Saturday after the sun is down to bid the holy day of rest farewell in a ceremony marking the beginning of the regular days of the week. By the end of the fifteenth century, this style of lamp was used in Jewish homes exclusively for ceremonial purposes, a practice that lasted until modern times.

This lamp is one of the treasures in the history of Jewish art. It was designed and fabricated in the workshop of Johann Valentin Schuler, who, along with his brother Michael, produced some of the finest silver Judaica of their era.

The shaft of this elaborate lamp is similar to fountains found in public squares, and therefore it has been linked to "the fountain of blessing" recalled in the song "Lekhah Dodi," sung on every Sabbath. Star-shaped containers for oil and wicks hang from the shaft, and at the base a bowl is placed to catch the dripping oil. The lamp is associated with Hanukkah through one of the small figurines that stand at the top of the fountain. These were made from standard workshop molds, but Jewish hats, typical of the time, were added. Each sculpture also holds a different Jewish symbol associated with a separate festival of the Jewish year. One holds a menorah and an oil urn, indicative of Hanukkah. Another holds a shofar and a Book of Life, referring to Rosh ha-Shanah, while yet another carries a noisemaker and Esther scroll for Purim. In a similar hanging lamp by Schuler in the collection of the Jewish Museum in New York, Judah the Maccabee is dressed as a medieval knight, to suggest Hanukkah.

No evidence suggests that this lamp with its ten burners was used for kindling the Hanukkah lights, but it was used for the Sabbath and havdalah blessings on the nights these coincide with Hanukkah. On the Sabbath eve of Hanukkah, the Hanukkah lamp was always lit prior to the Sabbath lights because of their sanctity and the prohibition of doing any work once the Sabbath has commenced. Rabbinic law discusses the priority of buying a Sabbath lamp or a Hanukkah lamp if one has limited funds, and in Shabbat 23b Raba claims, "The Hanukkah lamp is preferable, on account of advertising the miracle."

Silver, cast, repoussé, and engraved. 22 1/4 x 14 1/2 in. diam. (56.5 x 36.8 cm diam.).
The Jewish Museum, New York, JM 37-52. Gift of the Jewish Cultural Reconstruction, Inc.

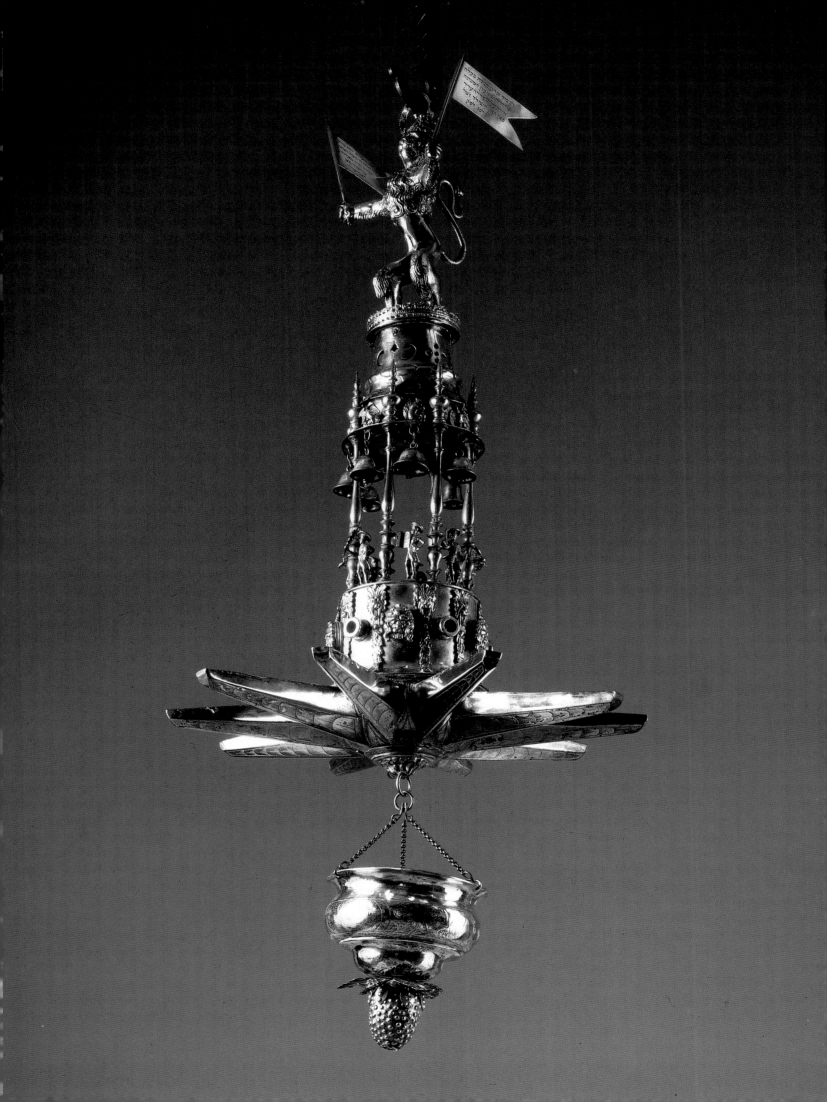

BOLLER LAMP

Johann Adam Boller

Frankfurt am Main, Germany, c. 1706–1732

Johann Boller fabricated Hanukkah menorahs of the candelabra type that the Schuler brothers (page 39), relatives of Boller, had originally made famous in Frankfurt a generation earlier. Like the six known earlier Schuler lamps of this type, the Boller lamp is an exquisite eighteenth-century artistic interpretation of the Temple's seven-branched menorah (Exodus 25: 33). The silver branches are decorated with knops but here bloom also with the addition of Boller's filigree flowers. In a stylistic innovation, Boller integrated into the shaft of the lamp the figure of the Lion of Judah, whose strength metaphorically supports the Jewish people.

The red-and-white enamel plaques affixed to the lamp's base depict scenes from the life of Jacob, including the rolling of the stone from the well, Rebecca's meeting with Eliezer, Jacob's dream, and Jacob wrestling with the angel. The surface of the lamp is gilt and adorned with engraved patterns and filigree work. Fully sculptural cast figures are added in an inspired and refined design.

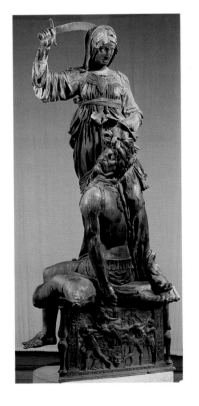

Judith, the ancient Jewish heroine who saved her people from destruction, stands triumphant at the top of the lamp. Her sculptural form, with raised right hand holding a sword and left hand grasping Holofernes's head, is related to Donatello's monumental Renaissance sculpture *Judith and Holofernes,* which once stood in the Piazza della Signoria in Florence. To the early Florentines, Judith was a symbol of moral virtue and civic strength. The inscription at the base of Donatello's Judith, applied in the middle of the fifteenth century, demonstrates the popular contemporary understanding of the apocryphal story: "Kingdoms fall through luxury, cities rise through virtues; behold the neck of pride severed by the hand of humility. . . . Piero son of Cosimo Medici has dedicated the statue of this woman to that liberty and fortitude bestowed on the Republic by the invincible and constant spirit of the citizens." The statue of Judith, much like Donatello's sculpture of David, who slew Goliath, became a proud public representation of the Florentine city-state, which had successfully preserved its autonomy against its adversaries.

Above: Judith and Holofernes. *Donatello. Florence, Italy. 1455–1457.*
Bronze with traces of gilding. Height 92 15/16 in. (236 cm). Palazzo Vecchio, Florence.
Right: *Silver, cast, engraved, filigree, hammered, and gilt, with enamel plaques. 17 x 14 1/2 in. (42.5 x 36.3 cm).*
The Jewish Museum, New York, S563. Gift of Mrs. Felix Warburg.

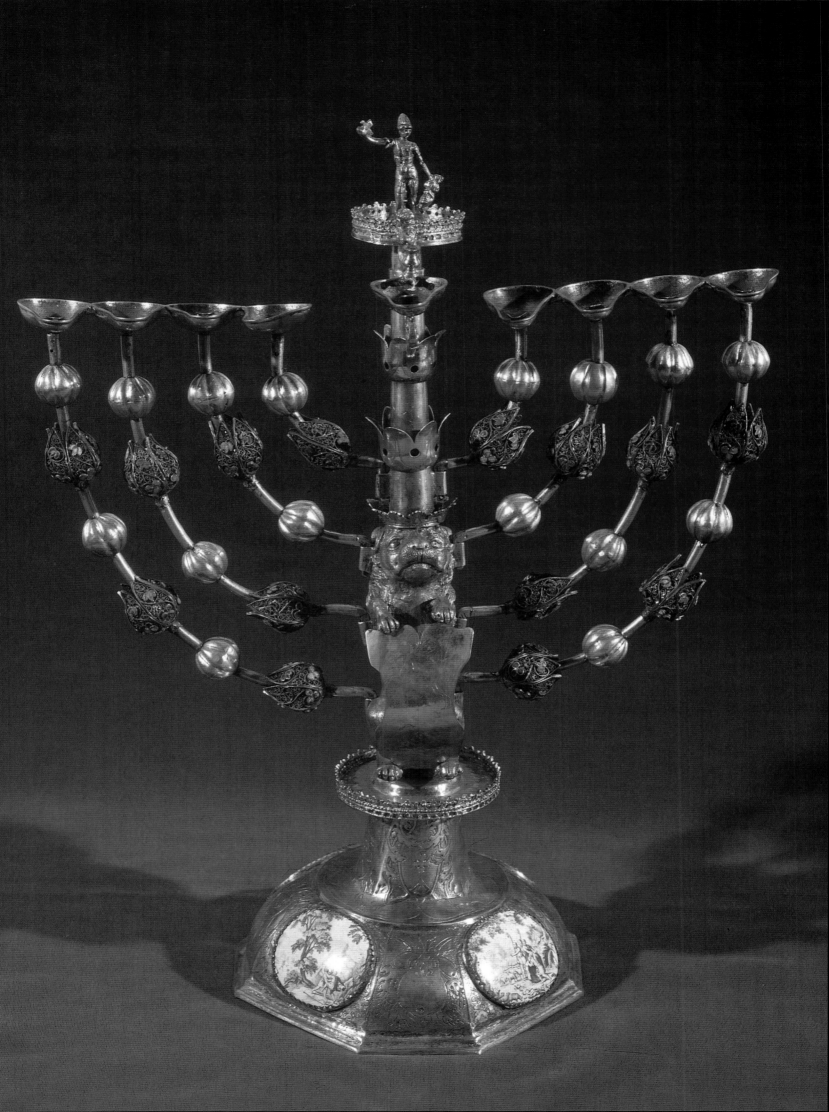

PEWTER BENCH-TYPE LAMP

Johann Philip Henschel (?)

Frankfurt, Germany, 1756

Bench-type Hanukkah lamps made out of pewter were popular in southern Germany in the eighteenth century. One reason is that pewter was a less expensive metal than silver or bronze, though it was also softer and therefore more easily damaged. Such lamps were often made by Jewish folk artists and scribes, called *sofrei stam* (writers of Torah, tefillin, and mezuzot), who did the engraving of word and image. They used pertinent motifs and texts on the backs of these lamps, just as they did on pewter Passover and Purim plates. Gentile fabricators made the basic forms, but the Jewish artists and scribes made the decorative and symbolic patterns.

An image of a man lighting a seven-branched menorah is engraved in the middle of the back panel of this lamp. This motif is familiar from eighteenth-century printed and hand-painted Jewish books such as *sefer minhagim* or books of blessings, which very easily could have been the source for this artist's rendering. However, in the books, the candelabra being lit is always an eight-branched Hanukkah menorah. Both the seven- and eight-branched menorahs are relevant symbols of Hanukkah. The one with eight branches represents the number of nights the holiday is celebrated, and the one with seven alludes to the menorah in the rededicated Temple. The Jewish yearning for the return to Zion, when the Temple will be rebuilt, is expressed in the engraved messianic symbols of both the Temple menorah and the stylized hands of the *cohanim*, the emblem of the priestly class who tended the Temple.

The 1756 date (in its Hebrew equivalent) is engraved at the top of the back panel of the lamp. The Hebrew letter *mem* (מ) is engraved twice, perhaps referring to the family name of the owner. At the top of the lamp is found a stamped hallmark, an angel with a sword in one hand and scales in the other; the use of the angel denotes the highest quality of pewter. Cast rampant lions decorate the side panels. One holds a pitcher of oil and another a barrel. In a similar lamp this barrel is the base for a pole that holds the shammash.

The bench-type Hanukkah lamp developed early in Jewish history. Because of its construction, with a backplate, sides, and feet or a tray at the bottom, this lamp style can stand on its own. The form was an adaptation from the hanging lamp type intended for public display in windows. This pewter lamp exemplifies the kind of lamp that could easily be brought inside so that "in times of peril one may place it on the table," as Maimonides suggested in the Mishneh Torah.

Pewter, cast and engraved; hallmark: angel with sword and scales. 7 ⅞ x 9 ¼ x 3 ½ in. (20 x 24 x 9 cm).
Stieglitz Collection. The Israel Museum, Jerusalem.

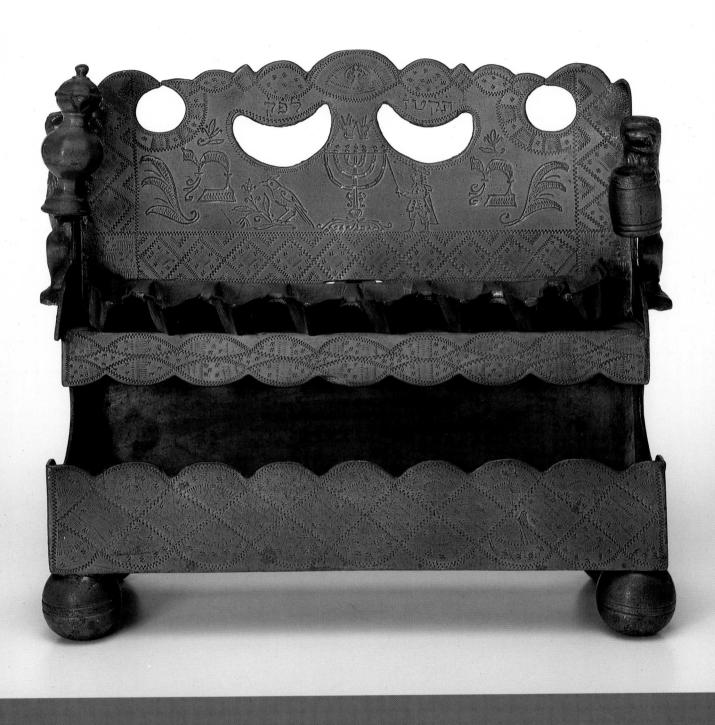

Judith and Holofernes
(from a Book of Blessings)

Artist unknown
Vienna, Austria, 1736

A renaissance in illuminated manuscript production occurred in eighteenth-century Europe. These elaborate books, including Passover Haggadot, collections of blessings to be said after meals, omer calendars, and circumcision manuals, were commissioned by wealthy Jews and knowledgeable art patrons for their own private devotion and ritual, often at home.

This resurgence of hand-painted Hebrew books appears to have begun in the first half of the century in Bohemia and Moravia. This book of blessings was made in Vienna in 1736. In many instances, these charmingly decorated books were signed by both the scribe and the illustrator, although in this small volume the colophon has been erased. What does exist, however, is an inscription on the frontispiece stating that this manuscript book was "given by the bridegroom Asher Anshel to . . ." Blessing books were often presented as wedding gifts by grooms to their brides, and among similar books in the collection of the Jewish Theological Seminary, the inscriptions read "For Hanna, daughter of Isaac Oppenheim" or "For Bella from Frankfurt" or "For Braindel, wife of Seckel Z'B'."

This colored miniature of Judith and Holofernes illustrates the pages dedicated to the Hanukkah blessings. In almost every other home blessing book, including those dedicated to women, the illustration for the *al ha nissim* prayer is a male figure lighting the Hanukkah lights. Although a long Jewish art tradition associating Judith's heroism with that of the Maccabees exists in the art of Hanukkah, this choice of subject matter for a prayer book is rare. It suggests that the commissioner of this book, most likely a groom, wished to customize it for his bride, as this book includes three prayers customary for devout Jewish women. These blessings, each fully illustrated, are for the taking of challah, the performing of the mikvah (ritual bath), and the lighting of the Sabbath candles. Also illustrated in this book are the blessings for vegetables, fruit of trees, and fragrant plants; a prayer to be said for the sick; prayers to be said upon seeing lightning, hearing thunder, seeing strange creatures, beholding the sea, or seeing a rainbow; and a prayer to be said before retiring at night.

The diminutive size of the book made it perfect for keeping in a pocket throughout the day to retrieve as needed, and for holding easily in one's hand as prayers were recited.

Vellum, original tortoiseshell binding. 3 1/2 x 2 5/8 in. (8.9 x 5.6 cm). Ms. 4789. The Library of The Jewish Theological Seminary of America, New York.

וְעַל הַגְבוּרוֹת וְעַל הַתְּשׁוּעוֹת
וְעַל הַמִּלְחָמוֹת ֿ שֶׁעָשִׂיתָ
לַאֲבוֹתֵינוּ בַּיָּמִים הָהֵם בִּזְּמַן
הַזֶּה:

מן חנוכה זהנט מן בניי וּתתיהו וכו׳:

RINTEL LAMP

Peter Robol II

Amsterdam, The Netherlands, 1853

This large-scale silver candelabra originally stood in the Great Synagogue of Amsterdam, which was built in 1671. The inscription on the silver plaque above the centrally placed shammash gives the lamp's provenance: It was a gift to the synagogue by the *parnas* (trustee) Chaim Levi, son of the *parnas* Josep Levi and his wife, Sara, daughter of Isaac Rintel, on the first day of Hanukkah (December 21), 1753. Fashioned by the fine Amsterdam silversmith Peter Robol II, this sophisticated and costly lamp was given to Amsterdam's first major Ashkenazi synagogue at a time when Holland's Ashkenazi Jewish community had recently superseded the Sephardi community in wealth, numbers, and prominence.

This Hanukkah menorah is an artistically sophisticated example of the decorative arts. Its elegant proportions, the wide and embracing lilt of the arms, and the intricacy of the decorative elements combine to create a refined and inventive work. The impression is simultaneously of strength and of delicacy. The branches consist of highly articulated floral forms, which may be stylized irises. Below the lintel that carries the candleholders hang eight bells, reminiscent of the biblical description of the bells that adorned the hem of the robes of the high priest Aaron. Lost today is a carved pedestal that once held this lamp aloft.

The menorah was placed to the right of the monumental marble Torah ark in the Great Synagogue as a reference to the seven-branched candelabra that stood in the Temple in Jerusalem. The lamp's shape originates from the same source, and it represents a tradition begun in medieval times, when synagogues in Europe maintained large standing eight-branched menorahs for travelers to celebrate Hanukkah away from home. A manuscript illumination of the Gothic period (page 23) depicts the Temple menorah, which was used as a model for the eight-branched lamp in the synagogue. The symbolic reason for adopting this shape for the synagogue lamp was the inherent reference to the Temple in the meaning of the Hanukkah prayers. Because of the permanent placement of these large standing lamps in European synagogues, the Hanukkah lamp became a year-round reminder of the messianic age, when the Temple would be restored.

Silver, chased, engraved, castings. 41 ⅜ x 52 ⅜ x 18 ½ in. (105 x 133 x 47 cm).
Jewish Historical Museum, Amsterdam. On loan from the Jewish community of Amsterdam.

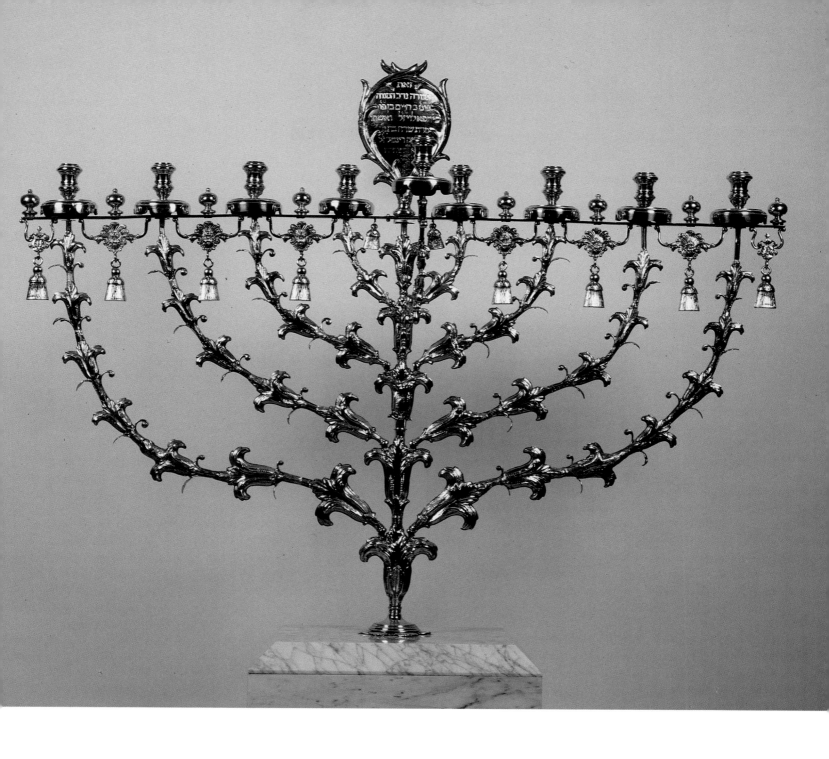

18TH-CENTURY DUTCH LAMP

Artist unknown

The Netherlands, 18th century

This brass sheet-metal bench-type Hanukkah lamp is typical of the decoration and design of Dutch secular folk art brass lamps of the eighteenth century. These secular lamps usually held a single candle; Jews adapted the popular form for Jewish purposes by substituting a row of eight cast fonts (for oil and wicks) for each candle. Jewish symbols or Jewish interpretations of general symbols added religious meaning to the ritual object.

It has been suggested by Chaya Benjamin, associate curator of Judaica at The Israel Museum, that this lamp might have been made for a commemorative event because of its crowned tentlike form and the repoussé balloons on the side panels. A stork with a worm in its beak, which is the symbol of the capital city, the Hague, is found on the front, alluding to the lamp's place of origin. The crown—which in Jewish art most often refers to the crown of Torah—is elaborately detailed with beading and hatching and is flanked by waving streamers. Recalling the pennants often appended to festival tents, the ribbonlike flags are a typical rococo decorative convention.

The most compelling depiction is that of the two simply rendered figures carrying a plentiful cluster of grapes between them. One is dressed as an eighteenth-century bourgeois urban gentleman with top hat and waistcoat. The other, in a wide-brimmed hat, wears peasant or country attire. Sprouts of vegetables and grains push up from the ground at their feet, alluding to the fertility of the soil. This image dramatizes the biblical story (told twice, both in Numbers and in Deuteronomy) of twelve spies, one from each of the twelve tribes of Israel, who have been sent ahead to scout out the land of Israel, promised them by God. They return to the Israelites, who have just escaped from Egypt and are in the desert, reporting that indeed Israel is a land flowing with "milk and honey." Only two of the spies, Caleb and Joshua, are confident that the people can and should conquer the land, claiming that they shall surely overcome the inhabitants already there and that faith in God will ensure their success.

The Two Spies became a messianic symbol in later generations. In the twentieth century they developed into a popular visual icon of Zionist ideology, coming to stand for the return to Israel for which diaspora Jews, spread throughout the world for centuries, had yearned so long. The grapes in their fullness represent the spiritual sustenance of Israel as both a dream and a reality.

Sheet brass, repoussé, cut, and punched; cast oil fonts. 20 ½ x 11 ⅞ x 3 ⅞ in. (52 x 30.5 x 10 cm).
Stieglitz Collection. The Israel Museum, Jerusalem.

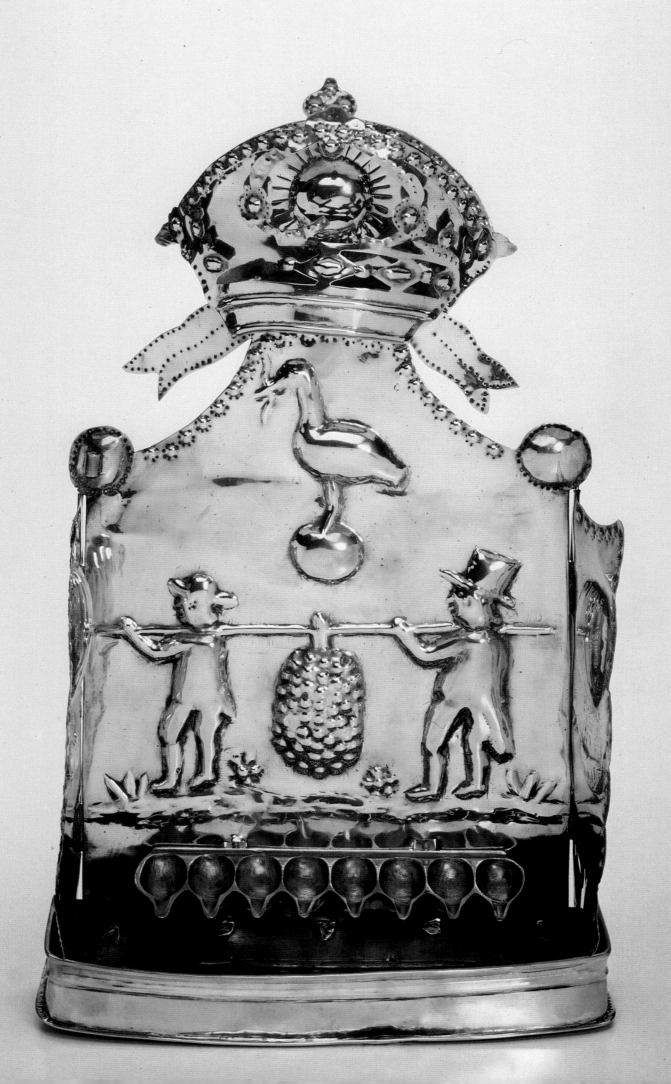

BRODY LAMP

Artist unknown

Brody (Galicia), 1787

This elaborate Hanukkiah is an elegant example of the high baroque and rococo decorative arts of the German lands in the mid- to late eighteenth century. Architecture informs the shape and style of many types of Hanukkah lamps because of the symbolic association with the Temple in Jerusalem, the rededication of which is reenacted in the holiday's ritual. This magnificent lamp is an effective example of this architectural metaphor. Its design is derived from the style, spaces, and ornament of rococo church interiors so magnificently exemplified in the high altar of the Abbey Church of Vierzehn-heiligen.

More precisely, the Brody lamp is a direct reference to the contemporaneous Torah arks of synagogues in Germany and Poland, which themselves were influenced by the interior decoration and high altars of rococo churches. The greatest art of this period emerged in music and architecture; highly controlled and energetic, it easily evokes strong emotional and spiritual responses. This charged spirit is evidenced in the never-ending rhythmic and decorative patterns of the lamp's surface. Abundant design elements include scrollwork, cartouches, drapery, flora, fauna, vases, and heraldic imagery. Synagogue Torah arks and church high altar architecture are the bases for the structural design elements of spiral columns, entablature, and ark doors. The several stories in this lamp are similar to the multiple stories seen also in ecclesiastical arks and altars, which focus the eye upward into soaring, dominant spaces in an architectural strategy to evoke the spiritual.

The Jewish symbolism of the piece is rich and well integrated into its Torah ark–like composition. The burners of the Hanukkah lamp are fashioned in the shape of lions, recalling the biblical Lion of Judah, and the crown capping the ark doors is a reference to the "crown of Torah."

Above: *Balthasar Neumann, architect. High altar of Vierzehnheiligen, Pilgrimage Church of the Fourteen Helper Saints. Franconia (Germany). 1743–1772.*
Right: *Silver, repoussé, openwork, appliqué, chased, cast, cut out, and parcel gilt; 27 ½ x 17 ⅜ in. (69.8 x 44.1 cm).*
Master: BZK. The H. Ephraim and Mordecai Benguiat Family Collection. The Jewish Museum, New York.

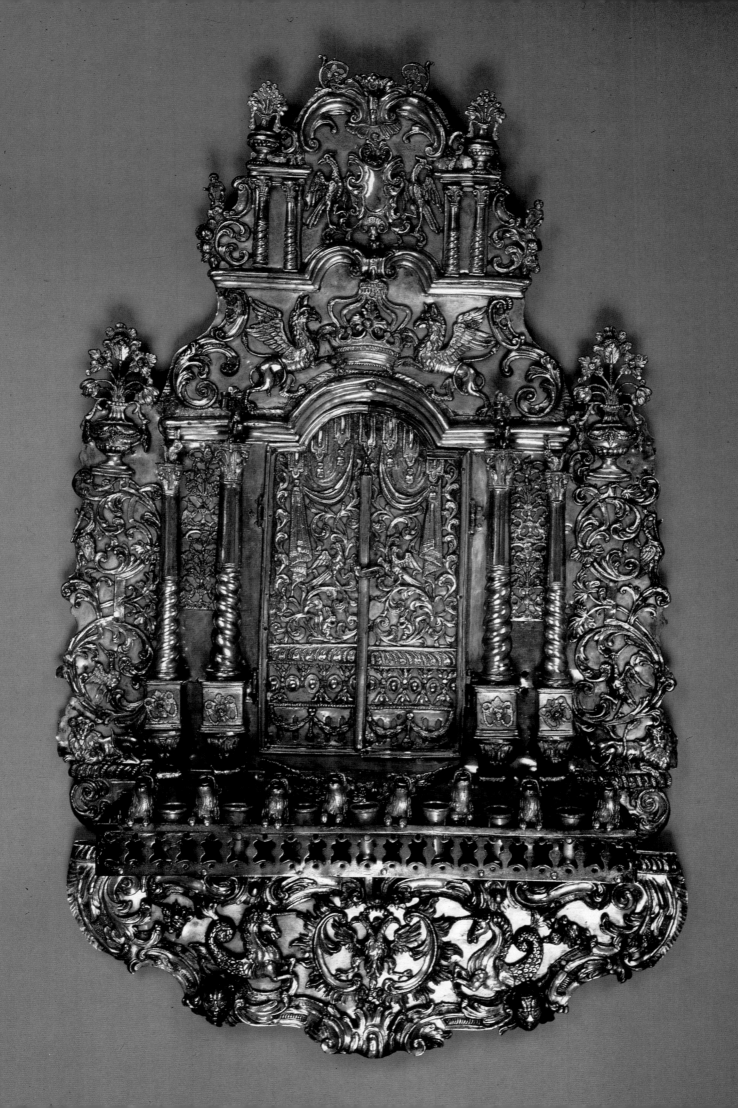

POLISH BRASS LAMP

Artist unknown

Poland, 18th century

This Polish brass Hanukkah lamp exemplifies the close relationship between synagogue architecture and the artistic and symbolic elements found in many Hanukkiot. The ubiquitous wooden synagogues constructed in Poland in the eighteenth century were the model for the elaborate architectural facades of this lamp type. Imitative of the structure and detail of the Jewish community's house of worship, the lamp's features recall a building of several stories, a balcony and railings with eight windows (indicating the women's section of the synagogue), a sloped roof with zigzag patterns and two chimneys, a central doorway flanked by two pillars, and large, open, inviting windows. Intricate trellislike work, similar to that found on wooden synagogues, is placed across the bottom, shielding the eight oil containers. Atop the lamp is an abstract animal and vegetation design often found in Polish folk art. Rampant lions make up the side panels, and the shammash is affixed to the right upper wall.

Similar to the German pewter lamp (page 43), this Polish lamp has feet and side panels, which make it possible for the lamp to stand on the table or hang on a wall. Echoing Maimonides, who was writing at an earlier time,

the Shulhan Arukh, a sixteenth-century book of Jewish legal interpretations, acknowledged the "precept to light the Hanukkah lamp at the entrance [of the house] near the street to commemorate the miracle; [as] it was done in the time of the Talmud. However, since we now live among non-Jews we light inside the house."

It is most likely that a candleholder is missing from the left side of this lamp; it would be a twin to the shammash, which protrudes from the side panel on the right. Many other lamps of this type have both such sockets intact. It has been surmised that these were used for the Sabbath lights either on the one or two Shabbats of the eight-day festival of Hanukkah or on other Shabbat observances throughout the year. Rabbinic discussions have centered on questions such as which to light first, the Sabbath or Hanukkah candles, and which takes priority if one is too poor to purchase both the Sabbath candles and the oil for Hanukkah lights. The rabbis seem to have agreed that the Hanukkah lights are lit first, but they have continued to debate whether the Sabbath candles or the Hanukkah lights should be bought first if one has limited funds.

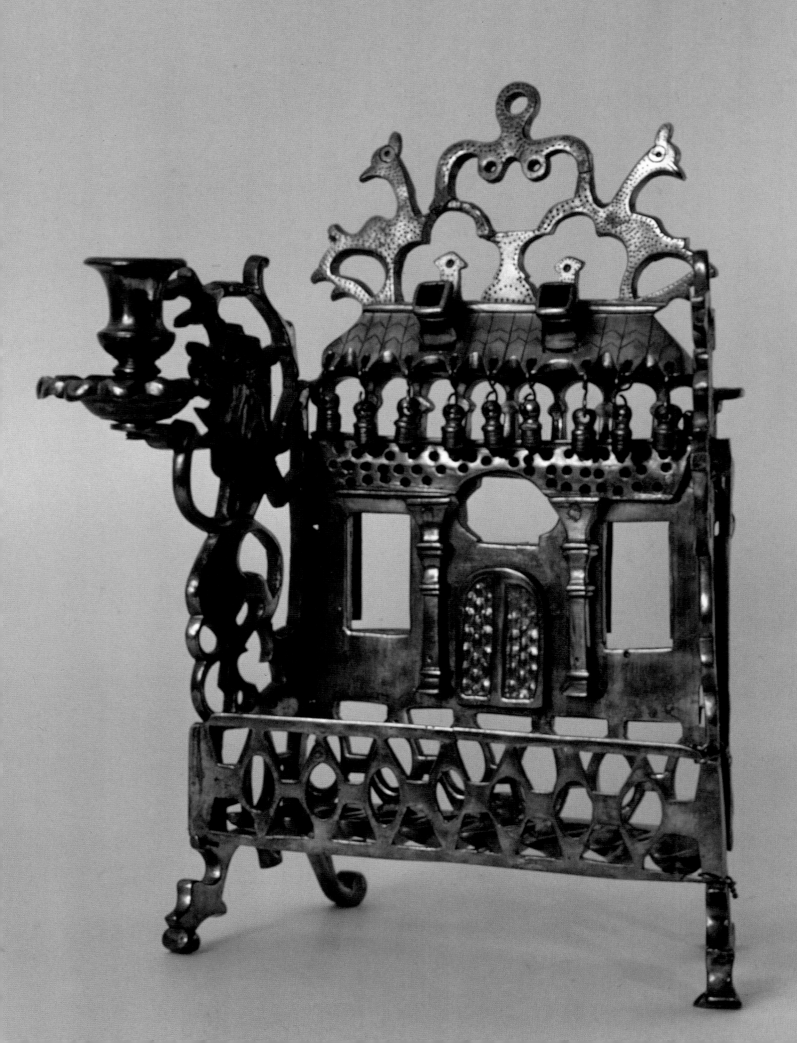

NORTH AFRICAN LAMPS

Artist unknown

North Africa, 18th–20th centuries

North African Hanukkah lamps have an elaborately decorative sensibility imbued with the artistic spirit that sprang from Moorish Spain and North Africa. These lamps have inherited a visual tradition characterized by the arabesque, a never-ending cursive line that extravagantly and sinuously fills every space and surface in a lush and crowded garden of line and lacework patterns.

These extraordinary examples from the Israel Museum's collection of Hanukkah lamps exhibit a synthesis of form and motif derived from the architecture of palaces and mosques. The highest point of refinement in the architecture of the Iberian peninsula was that of the Alhambra (pictured), which codified the aesthetic standard and has influenced the arts of the entire Islamic world ever since. The pointed arch and the intricate geometric patterns that articulate the walls of this sublime chamber of the Moorish palace are repeated continuously as the ideal structural and spiritual form. The *mirhab* arch of the prayer niche, which is similarly pointed, indicates the direction of Mecca, toward which worshipers face while praying. This overall shape has influenced the form of all the decorative arts from

this region, including Hanukkah lamps, for centuries.

Islamic law forbids artists to represent humans or animals, and so Jewish objects made in that part of the world also tended to be devoid of obvious or natural human figuration. Occasionally animal or bird images would be incorporated in a highly decorative or stylized way, as in the Hanukkah lamp from Tetuan.

The Algerian lamp invokes a two-story building with a colonnade of pointed arches, each containing an oil burner. The shammash inhabits the middle arch on the upper level. The flat, unadorned back panel, with three domelike shapes, is reminiscent of the multidomed structures of mosques.

The Tetuan lamp is richer in identifiable Jewish imagery, such as the seven-branched menorah, which appears on Hanukkah lamps throughout the world, and the Hebrew blessings atop the menorah and in the two oil amphoras above the eight oil burners. The elaborately decorated lamp from Fez defines three pointed, arched windows and three quatrefoils surmounted at the top by an inscribed Star of David. An opening for the shammash (missing) is below the star.

Above: *Mirador de Lindaraja. Alhambra, Granada. Finished 1370.*
Left to right: (far left) *Fez, Morocco; 19th or 20th century; brass, cast, pierced, and engraved; 14 ⅛ x 9 ½ x 3 ⅞ in. (36 x 24.2 x 9.9 cm);*
(front) *Morocco; 19th century; brass; 8 ¼ x 5 in. (21 x 13 cm);* (rear) *Tetuan, Morocco; 18th or 19th century; brass, engraved, pierced, and cast;*
12 ½ x 9 ⅜ x 3 ⅞ in. (31.7 x 24.4 x 6.5 cm); (far right) *Algeria; 19th century; copper, brass, punched, engraved, pierced, and cast;*
11 ⅞ x 11 ⅜ x 2 ⅞ in. (30.1 x 28.7 x 7.4 cm). All lamps, The Israel Museum, Jerusalem. Gift of Z. Schulmann Collection, Paris.

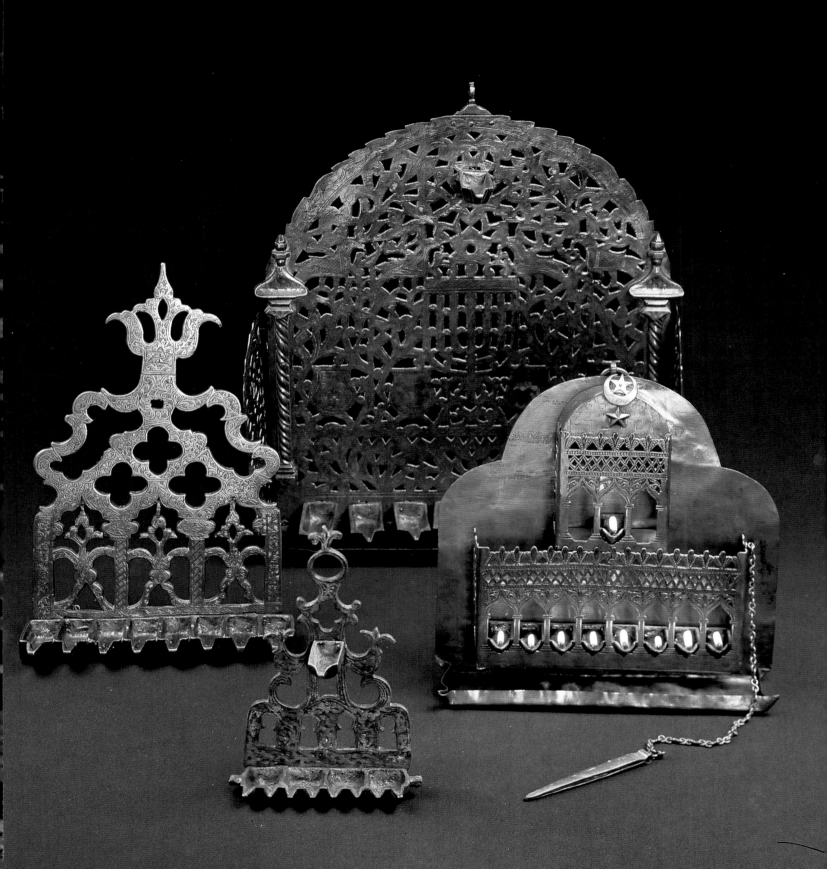

"OAK TREE" LAMP

Artist unknown

Lemberg, Poland, c. 1800

This Hanukkiah is a unique Judaic artistic creation. It is a sculptural silver and gold landscape, a menorah in the shape of a resplendent oak tree rendered in naturalistic detail, with graceful leaves, rough bark, and plentiful acorns. The tree emerges from a low hill teeming with the flora and fauna of the forest, including rabbits, a dog with her pups, a squirrel, worms, and a caterpillar. This sets the pastoral stage for a human drama highly unusual in Jewish art representations. A golden bear climbs up the tree trunk, seeking a honey pot (near which a bee hovers). The pot has been placed on a low branch as a lure by the youth hiding in the foliage at the back of the lamp at its tallest point. From below, a hunter kneels and aims a rifle at the unsuspecting hungry bear.

A Polish folk motif likens the Torah to honey: Humans pursue the knowledge within as hungrily as this bear seeks the honey. Another supposition is that the wealthy owner of this lamp may have been a hunter himself and enthusiastically commissioned this drama as a personal emblem. Yet another interpretation suggests that the patron may have been named Ber, a popular eighteenth-century Ashkenazi name.

The lamp has no maker's stamp, but it does have sev-

eral other marks, one of which was required by the city of Lemberg as a tax stamp for all silver made or bought in the city in 1806–7. It was the custom of Jewish silver- and goldsmiths in Eastern Europe of the time not to sign their work, and it is therefore probable that one of them was this lamp's maker. Franz Landsberger, former Curator of the Hebrew Union College collection, has written extensively on this lamp, explaining the seeming contradiction between the joyful depiction of man and animals and the occasional rigid interpretation of the Second Commandment, which might have inhibited such natural representation. Landsberger points out that an enlightened Jewish community in Galicia at the time allowed for the study of the natural sciences, among other disciplines, in addition to the traditional study of Bible and Talmud.

The "oak tree" menorah is a powerful interpretation of the biblical menorah that stood in the Tent of Meeting and the Temple in Jerusalem. The ancient menorah was a seven-branched lamp symbolizing a "tree of life." With this realistically precise depiction of a tree as a Hanukkah lamp, the menorah's meaning comes full circle.

Above: *Detail of bear climbing the tree.*
Right: *Silver, cast, repoussé, chased, parcel gilt. 26 x 11 in. (66 x 27.9 cm). HUC 27.100.*
Hebrew Union College Collection. Skirball Museum. Skirball Cultural Center, Los Angeles.

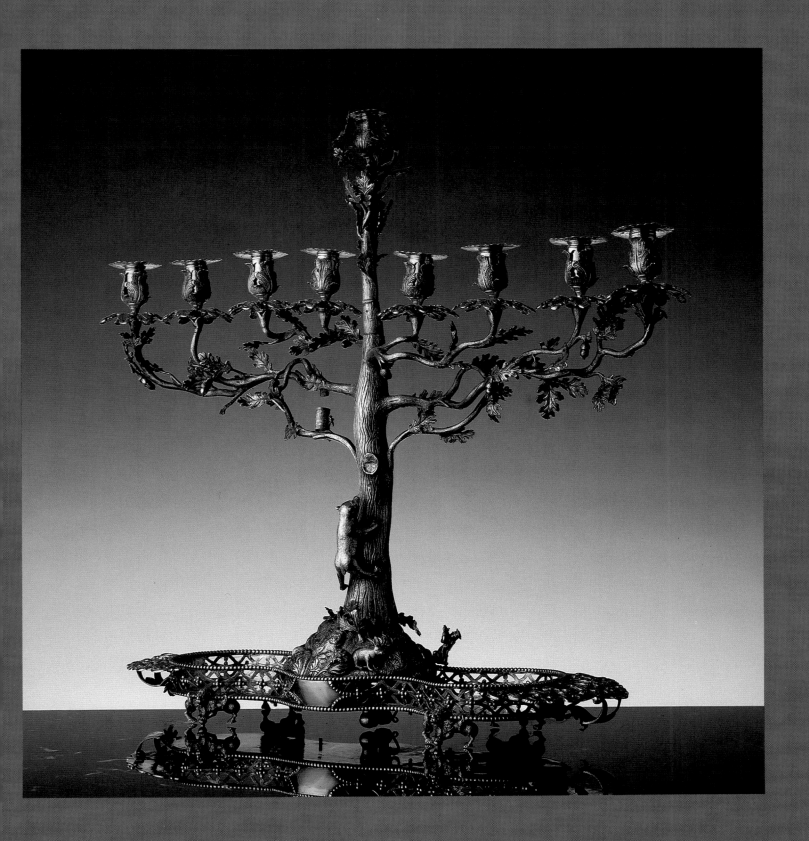

MIRROR LAMP

Artist unknown
Germany, 18th century

This fanciful Hanukkah lamp exudes the charm and intimacy of the joyous home celebration of Hanukkah. Constructed of wood and covered with mirrors and glass, this Hanukkiah bears the artistic stamp of the crowded and sometimes sweet and sentimental style of the late rococo period. The allover etched scrollwork patterns transform the object into a latticed garden, as if wisps of springtime buds were pushing their way through the earth to light and air above.

The lamp's overall shape relates to other Hanukkiot that were adaptations of the grand synagogue arks of Eastern European houses of worship. However, the scalloped contours at the top of the back panels and the wide bar upon which the oil burners sit give this object a proportion and scale reminiscent of a sanctified altar. There is also the sense of a musical instrument—perhaps a diminutive pianoforte or even a circus calliope. The exuberant etched decorations, the mirrored reflections that create a lively flicker of the play of light and dark, and the emphasis on abstract design, in contrast to more serious or formal symbols typically found on many Hanukkah lamps, provide this lamp with the celebratory and intimate quality of the festival for which it was made. One can imagine upper-middle-class German Jews in prosperous homes lighting this lamp in service of the requirements of the Jewish holiday.

The dominant Jewish motif on the lamp is the blessing over the Hanukkah candles, which is inscribed in the center of the back panel. A similar treatment is seen in the sixteenth-century German lamp (page 37), in which the ancient and traditional Hanukkah prayers and blessings have been incorporated as the lamp's one clearly identifiable symbol of Hanukkah other than the burners for eight lights. Above the inscriptions is a schematic design of a fringed canopy, which could be alternatively interpreted as the image of the crown of Torah often used on Jewish ritual art.

Wood, glass, mirrors, letterpress on paper. 13 ¾ x 13 ⅜ in. (35 x 34 cm).
The Israel Museum, Jerusalem. Gift of the Ticho Collection.

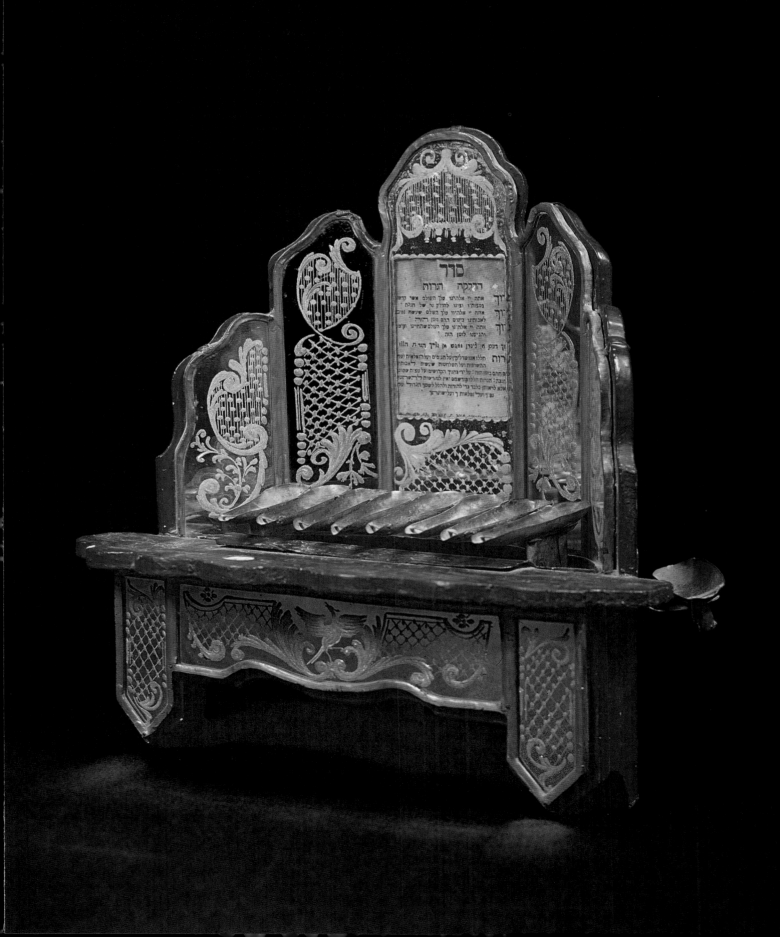

HIRSCH LAMP

Artist unknown

Germany, 1814

This monumental bench-type Hanukkiah makes dramatic use of a tradition in which the shape of a Hanukkah lamp reflects the architectural style of the period and place in which it was made; indeed, the Karlskirche in Vienna shares some features with this lamp. The lamp's realistic and detailed facade combines the triangular pediment, Corinthian columns, and stone masonry foundation typical of the architecture of the period. The silver and gilt metal sheet at the back of the lamp bears a naturalistic representation of a charming townscape, complete with another building, fountain, animals, and birds. However, the bold architectural statement that informs this lamp has a far more profound source. It symbolizes the Temple in Jerusalem, the rededication of which is celebrated on Hanukkah by lighting a lamp. The burners on this lamp take the shape of crowned rampant lions, with their lower jaws forming wickspouts. The three blessings recited for the kindling of the Hanukkah lights are engraved in Hebrew in the lunette at the bottom of the lamp.

The date of this lamp, 1814, was deduced by adding the numerical value of the Hebrew letters emphasized by gilt dots applied to the inscription on the lamp's pediment: "Then Samuel took a vial of oil and poured it on the branches of the menorah" (I Samuel 10:1). This choice of a biblical verse mentioning Samuel combined with the Hebrew letters that spell Samuel applied twice to the rampant stags at the top of the lamp suggest that the first name of the owner was Samuel. The fact that the German word for "stag" is *Hirsch* has led scholars to conjecture that owner's full name was Samuel Hirsch. Another Hebrew inscription along a band below the gilt roof and dome of the repoussé back panel reads, "A woman Judith redeemed a forgotten nation: May her goodness be remembered for a blessing." Because the gilt dots over Hebrew letters in this quote indicate the name *Gittel* or *Gutel*, it is thought this may be the name of Samuel Hirsch's wife. A charming and functional aspect of this lamp is the inclusion of implements necessary to perform the ritual lighting of the lamp: a basket for wicks, an oil funnel, a hammer, a shovel, a spouted jug, and a bucket.

Above: *Fischer von Erlach and Johann Bernhard, architects. Karlskirche (Church of Saint Karl Barromaeus). Vienna. 1723–1739.*
Right: *Silver, repoussé, chased, engraved, cast ornaments. 28 x 22 ¼ x 5 ½ in. (71.1 x 56.6 x 14 cm). HUC 27.70.*
Hebrew Union College Collection. Skirball Museum. Skirball Cultural Center, Los Angeles.

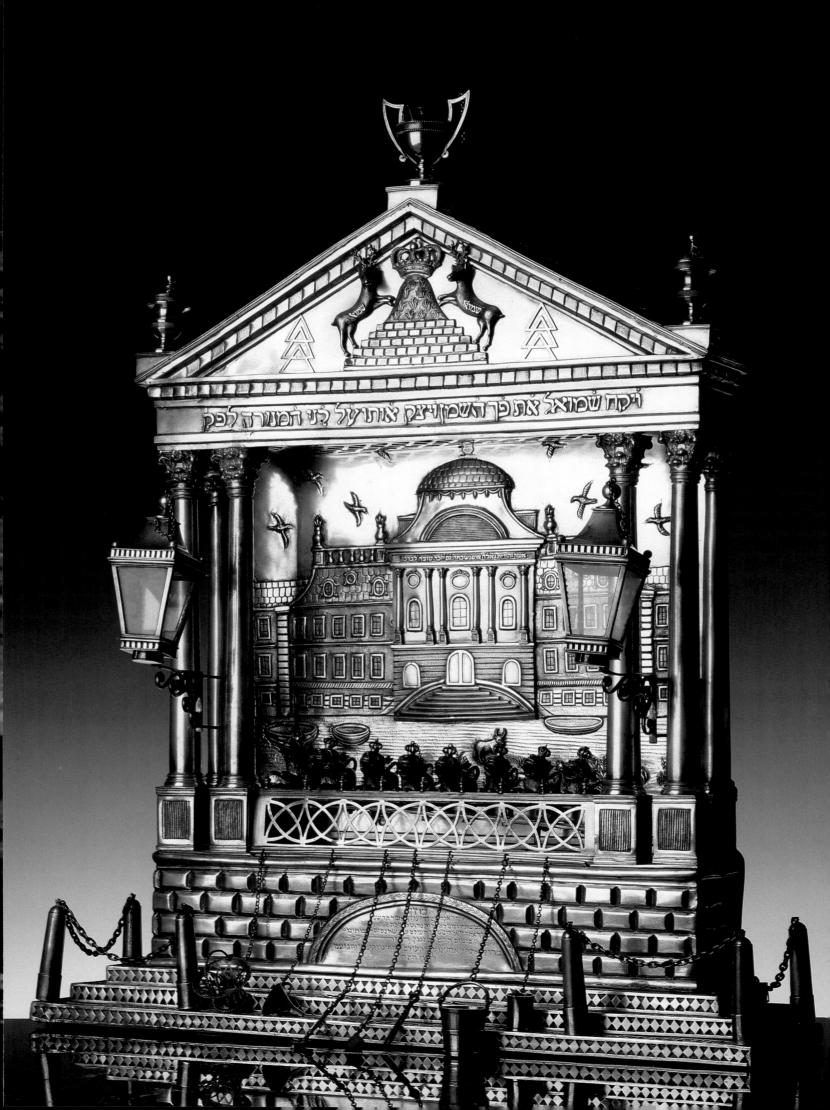

ROTHSCHILD LAMP

Johann Heinrich Philip Schott Sons

Frankfurt am Main, Germany, c. 1850

The Rothschild family crest is emblazoned on the base of this classic and formally beautiful silver candelabra. This definitive identification mark in the form of the family's baronial escutcheon provides the provenance so rare in most objects of Judaica. The lamp's ownership can be attributed to Baron Wilhelm Karl von Rothschild and Baroness Hannah Mathilde von Rothschild, well-known German Jews. The coat of arms was granted to the Rothschilds, along with baronial status, by an imperial decree to the family in 1822. The quartered shield consists of: upper left, an eagle, in reference to the imperial Austrian coat of arms; upper right and lower left, an arm grasping five arrows, a family symbol indicating the unity of the five Rothschild brothers; lower right, a lion rampant; center, another shield with the medieval funnel-like hat worn by Jews. The five roundels in the crest's crown refer to the various branches of the family. The exquisitely cast silver unicorn and lion, which stand rampant to protect the family crest and its heritage, are fully sculptural forms representative of the British branch of the family.

The maker's marks on the lamp are clearly stamped and easily readable: *Schott* indicates the workshop of Johann Heinrich Philip Schott Sons, and the hallmark has a *13* surmounted by a crown, a mark used in Frankfurt in the mid-nineteenth century.

The history of this object, which can be traced for over a hundred years (that itself is unusual in the collecting of Jewish ceremonial art), represents both the heights and the depths of the modern Jewish experience. This magnificent neoclassical Hanukkiah is thought to have been a wedding present from Baron Wilhelm Karl von Rothschild to his wife. When Frankfurt's Jewish museum was established in 1901, the year in which the baron died, it was named the Rothschild Museum. The lamp became a part of this museum's collection, and it was included in an important article published in 1937 by the art historians Hermann Gundersheimer and Guido Schoenberger, who worked at the Rothschild Museum after being discharged by the Nazis from their secular posts in the early 1930s. During the war, the Frankfurt History Museum preserved the collections of the Rothschild Museum and the Frankfurt synagogues, including this menorah. After the war, the Jewish Cultural Reconstruction, Inc., founded in 1947 to recover and redistribute Nazi-looted and heirless property, entrusted Hebrew Union College in Cincinnati, Ohio, among other like institutions, with this and other museum-quality objects of Judaica. The menorah came west to Los Angeles when Hebrew Union College's entire collection was moved to the Skirball Museum in 1972. This piece stands as testimony to the value of the Jewish tradition for which it was made as well as the tenacity of that tradition, which preserves and transmits its values to future generations.

Silver, repoussé, cast. 21 x 19 in. (53.3 x 48.3 cm). HUC 27.6. Hebrew Union College Collection. Skirball Museum.
Skirball Cultural Center, Los Angeles. Gift of the Jewish Cultural Reconstruction, Inc.

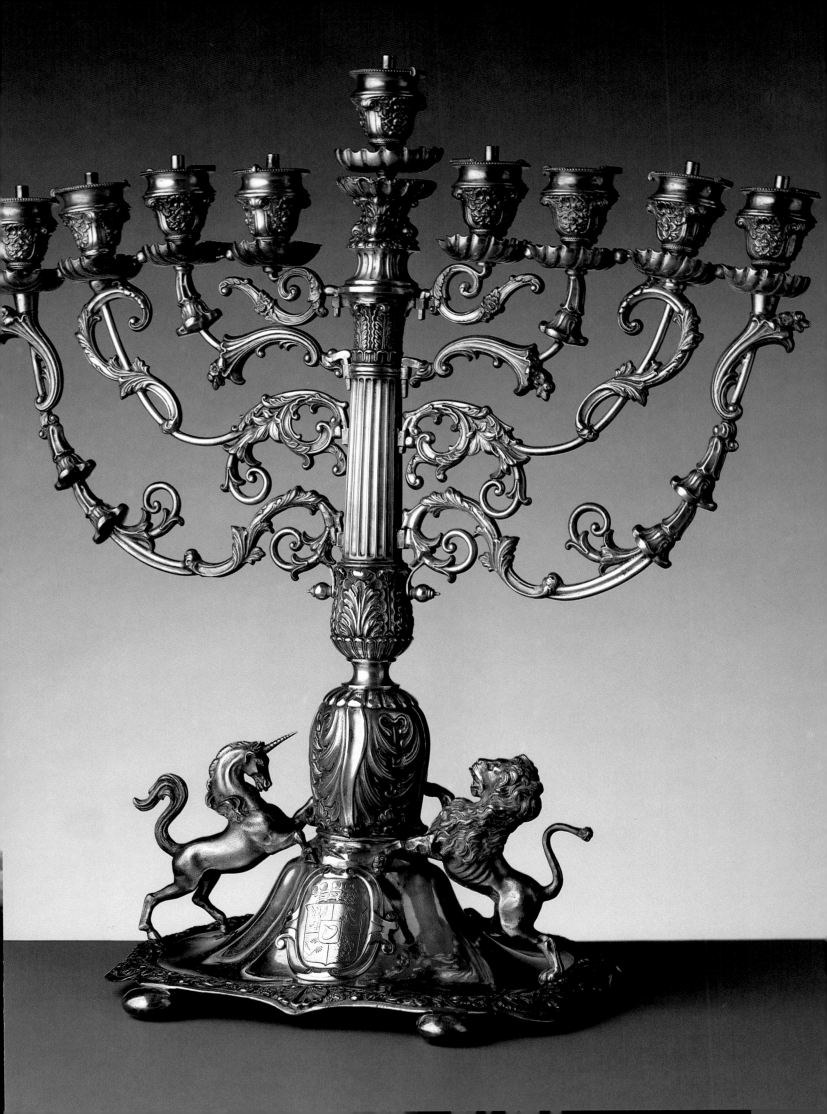

The Kindling of the Hanukkah Lights

Moritz Oppenheim
Frankfurt, Germany, 1880

Moritz Oppenheim is often called the "first Jewish painter" because of his well-known series of genre paintings depicting traditional Jewish life at the time of German Jewish emancipation in the nineteenth century. Born in 1800 in Hanau and educated in the art academies of Munich, Paris, and Rome, he eventually returned to Frankfurt, where he lived most of his life and where he died in 1882. He was a prolific painter of biblical and genre scenes as well as a sought-after master portraitist of wealthy and distinguished contemporaries, including the Rothschild family, major patrons of his work.

Between 1865 and 1880 he created a series of oil paintings of Jewish family life. Some of these, such as this painting, were in a medium called grisaille (the exclusive use of gray tones). The range of subjects in this group of compositions of Jewish religious life illustrate life-cycle events, Sabbath and holiday scenes, and historical Jewish events outside the ghetto. The significance of this body of work is that it indicates Oppenheim's courage and professional determination to use Jewish subject matter at a time when many Jews of the same level of society and education were converting to Christianity as a means of achieving economic, professional, or social success.

In Oppenheim's memoirs, written at the end of his life, he recalled a warm family childhood in a prosperous and religious home full of fine ceremonial objects.

Although his family was deeply committed to Jewish observance, they were also acculturated to the larger German society in terms of social, educational, and cultural pursuits.

The tender nostalgia of the Hanukkah celebration in this work suggests the artist's childhood memories as well as his lifelong conviction of the value of Jewish family religious experience. A comfortable upper-middle-class parlor, handsomely appointed with leaded glass windows, a grandfather clock, and the ever-present books of a Jewish home, is the setting for a holiday gathering in which several generations of family and friends celebrate the festival. A young boy with prayerbook in hand lights the candles of a Hanukkah lamp on the windowsill. There are numerous Hanukkiot in the room, which indicates the family has enough lamps for each participant to perform the mitzvah of lighting and blessing the menorah. The men smoke pipes and play chess and cards, while the dreidel waits for the youngsters to begin the fun.

Pictures of Old-Time Jewish Family Life is a well-known book of reproductions of the cycle of paintings Oppenheim had done earlier, and it was published in many versions in the late nineteenth and early twentieth centuries. Oppenheim's compositions of Jewish genre scenes were highly influential for other artists. He is remembered as the first professionally trained and accepted painter in the history of art to have rendered Jewish life as an engaging and worthwhile subject.

Oil on canvas. 27 11/16 x 22 1/2 in. (70.4 x 57.2 cm). The Israel Museum, Jerusalem.

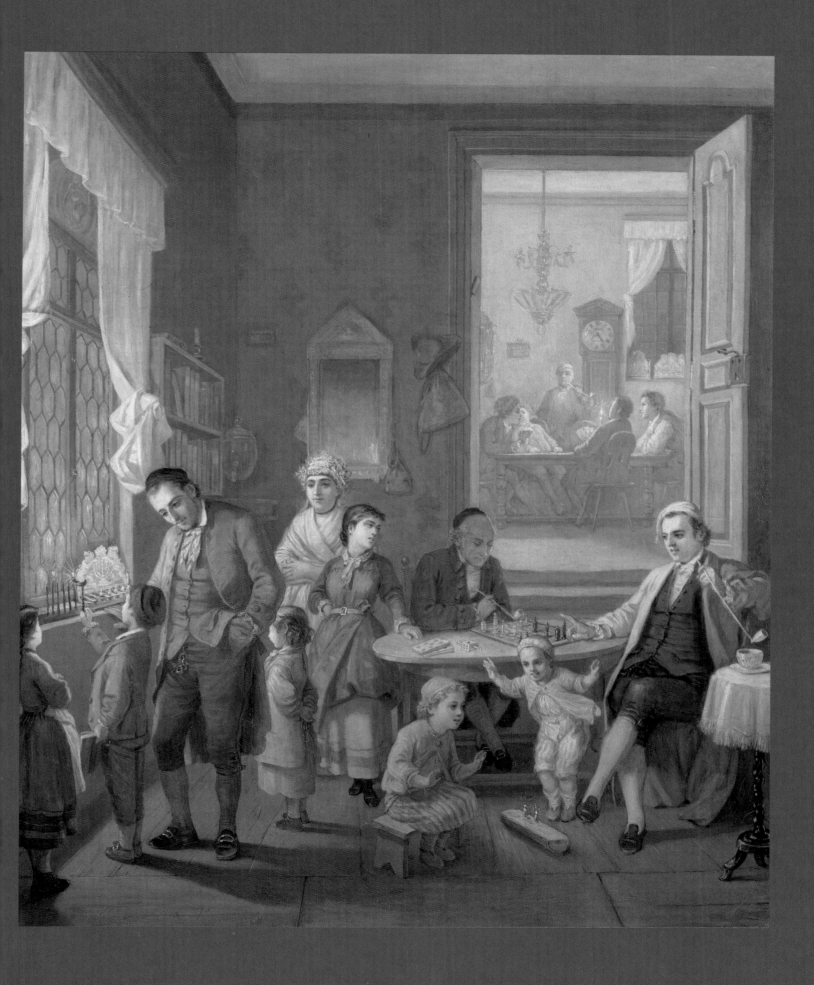

CHAIR LAMP

Artist unknown

Germany, late 19th–early 20th century

This set of diminutive chair-shaped oil lamps is a charming type of Central European Hanukkiah. The chair backs, with their elegant cursive lines, suggest the decorative arts and domestic-furnishing style typical of fin-de-siècle Austria and Germany and are reminiscent of the design aesthetic that emerged from the modernist movement of the Vienna Secession.

The chair backs are inscribed with the Hebrew words נר הנכה (*ner Hanukkah*)—light of Hanukkah—indicating the lamps are to be used exclusively for the festival celebration. The lights of Hanukkah are considered holy because of the ancient miracle they symbolize and may not be employed to illuminate normal activity, and so a special ninth light called a shammash or "caretaker" light, (here, a separate chair), accompanies the others.

The dollhouse quality of these miniature chair lights suggests they may have been made for and used by children, allowing young people to perform the ritual and participate in the fun of the occasion. They also bring to mind game pieces, recalling the games that are played during the evenings of Hanukkah (see Moritz

Oppenheim's painting *The Kindling of the Hanukkah Lights,* page 65). Jewish practice has always had the wisdom to create inventive and inviting age-appropriate ways to involve children in its ceremonies and teachings. For example, the Passover seder is replete with funny songs, stories, and games that help children understand the profound meaning of the holiday.

Although there is no evidence that the inventor of this lamp intended a reference to an ancient Jewish way of lighting the lights of Hanukkah, the use of individual oil lamps, each physically separate and distinct, has its roots in ancient tradition. The Judaica scholar who was also the first director of the original Israel Museum in Jerusalem, Professor Mordechai Narkiss, wrote in his seminal book *The Hanukkah Lamp* (1939) of the Greek, Roman, and Byzantine clay and bronze oil lamps used for the ritual lights of Hanukkah. For both the ancient lights and these nineteenth-century European ones, it is not known precisely whether another lamp was added each night or whether the entire set was put out with only the proper number of lights lit.

Pewter. 3 x 1 ⅛ x 1 ⅜ in. (7.6 x 2.9 x 3.5 cm). HUC 27.47.
Hebrew Union College Collection. Skirball Museum. Skirball Cultural Center, Los Angeles. Kirschstein Collection.

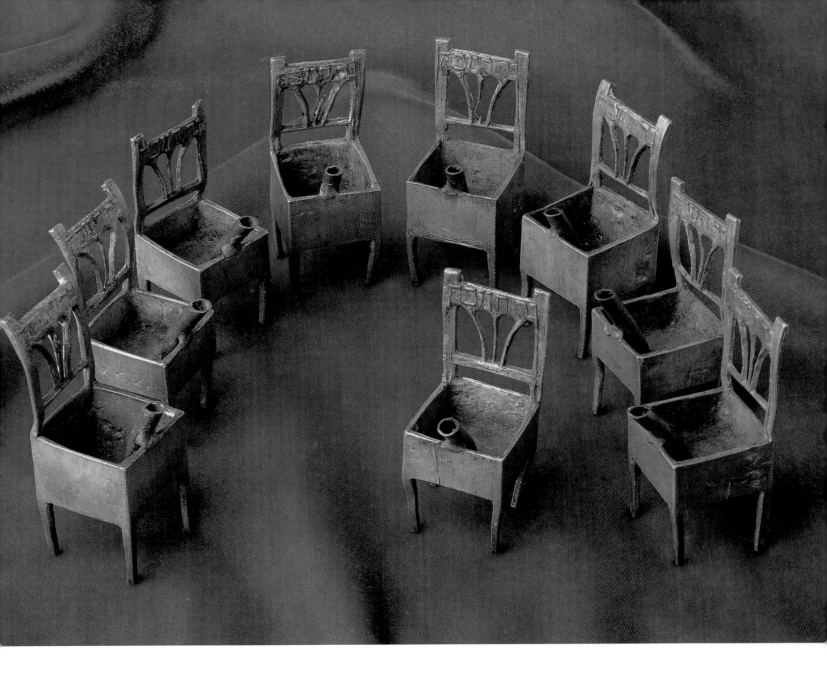

Lighting the Hanukkah Lamp

K. Felsenhardt
Poland (?), 1893

Lighting the Hanukkah Lamp, by K. Felsenhardt, offers a rare glimpse of Hanukkah in the home of a Polish Jewish family in the late 1800s. The stark room, without a window and with very simple furnishings, is indicative of a household of modest means. The young boys, dressed in their yeshiva hats and tzitzit, wear traditional Jewish dress of the time, like their father.

The Hanukkah theme of the painting is emphasized by the fact that the only objects in the room besides the furniture are those used to celebrate Hanukkah: the single plain Hanukkah menorah, a dreidel, and a prayerbook. The scene is cheerful and dignified as the family members enjoy the ritual and games of the happy Hanukkah evening. They participate in every aspect of the festival: lighting the menorah, blessing the lights, and playing dreidel. Felsenhardt has painted a tender genre scene extolling the values of Jewish family life and religious customs.

The image is one of a series of twenty-two gouache paintings of Jewish ritual- and holiday-themed works done by Felsenhardt between 1894 and 1897. It seems that the artist was influenced by Moritz Oppenheim's series "Old-Time Jewish Life" (see page 64). Oppenheim's works were reproduced in several versions and widely distributed throughout Europe. Until that time Oppenheim was the only Jewish artist painting documentary scenes of Jewish ritual and customs.

Although Felsenhardt's painting is one of great simplicity and directness, it is also artfully and dramatically composed and coloristically sophisticated. It has an authentic spirit without any oversentimentalization of the event. Compared to a similar scene of a German family in Oppenheim's painting, with its more-affluent decor and furnishings, the convivial party atmosphere, and the many Hanukkah lamps in the window, the Felsenhardt work reveals a family Hanukkah celebration far removed from such a worldly and enlightened environment.

Colored chalk and gouache on paper. 5 ⅛ x 9 ¾ in. (14.9 x 24.8 cm). HUC 66.79. Hebrew Union College Collection. Skirball Museum. Skirball Cultural Center, Los Angeles. Kirschstein Collection.

19TH-CENTURY WOODEN DREIDELS

Artist unknown

Germany or Poland, 19th century

*N*es gadol haya sham ("a great miracle happened there") is the message carried on every dreidel outside the land of Israel. It proclaims the essence and underlying theme of the Jewish celebration of Hanukkah. From the collection of the Jewish Museum in New York, these four dreidels allude to the joyousness of Hanukkah as a home-centered, custom-rich celebration going far beyond its formal religious rituals. One such tradition in Ashkenazi communities is the playing of dreidel. Popular songs learned by Jewish children in school, such as "I Have a Little Dreidel" and "Sevivon, Sov, Sov, Sov" ("Dreidel, Turn, Turn, Turn") attest to the popularity of the dreidel and the integral part it plays in the celebration of Hanukkah.

Among certain Jewish communities, Hanukkah nights have long been an occasion for playing cards and other games of chance while the lights were burning. In the Middle Ages it was common to occupy the evening with puzzles, charades, mystic numerology, Talmudic riddles, and acrostics. The game of dreidel—the name derives from the German *dreihen,* meaning "to spin or turn"—became popular in medieval Germany for Jews and non-Jews alike. The characters on each of the four sides of the dreidel were originally German letters indicating directions for play. For Hanukkah they were changed to the Hebrew letters that begin each of the four words of the phrase *nes gadol haya sham,* referring to the single day's quantity of oil found in the Temple, which, legend says, miraculously lasted for eight nights. Translating the letters into the Hebrew acrostic transformed the game into a reminder of the miracle that Hanukkah celebrates.

To participate in a game of dreidel, each player puts several chits—perhaps pennies, raisins, or nuts—into the center. Each player takes a turn spinning the dreidel, and when it lands on its side, the player who spun must take from or put into the center pot depending on the letter that lands upright: נ *(nun)* means to take nothing, ג *(gimmel)* means to take all, ה *(heh)* means to take half, ש *(shin)* means to put something in.

Symbolically, there are many interpretations attached to the dreidel. In one, the toppling of the dreidel is said to recall the "toppling" that took place when Judah the Maccabee's outnumbered forces defeated the larger and better-equipped army of Antiochus.

In Eastern Europe prior to World War II, yeshiva students prepared for Hanukkah by carving dreidels from wood or by casting lead dreidels from carved wooden molds. Next to the Hanukkah lamp, the dreidel is the object most closely associated with Hanukkah.

Wood. All dreidels, approximate height 1 1/2–3 in. (3.8–7.6 cm). The Jewish Museum, New York.

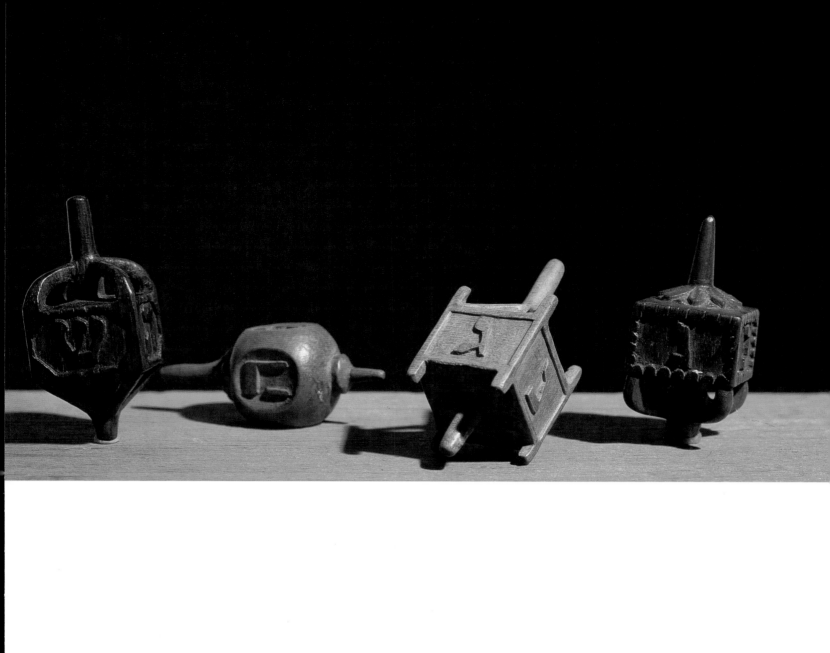

HAMSA LAMP

Artist unknown

Baghdad, Iraq, 19th century

This rare heirloom of Iraqi Jewish heritage is an exuberant work of folk art illustrative of the symbols and decorations utilized and adapted by Jews from the traditions of a country in which they had lived for centuries. When lit, this Hanukkiah would have had a dazzling presence, with a hot yellow glow from the brass and vigorous reflections of the flames contained in the glass cups, which would hang suspended from the brass collars. The cups were filled with water, and oil was floated on top to fuel the wicks. Flickering and mysterious shadows would be cast by this lamp because of its construction, materials, and the clear outline of its shape and symbols. The lighting of this lamp could have produced a dramatic and emotional atmosphere conducive to spiritual and religious ritual.

The most striking features on this lamp are the hamsas, or hand shapes (the term *hamsa* relates to both the Hebrew and Arabic words for "five"). Throughout North Africa and the Middle East, the hand image was invested with amuletic power to ward off the evil eye—the forces of darkness and bad luck. The fact that five hamsas can be found here underscores the profound belief in the number's potency.

Another practice Middle Eastern Jews employed to protect themselves from the evil eye was the use of a biblical quote. In Genesis 49:22 there is a play on the phrase "Joseph is a fruitful vine, a fruitful vine by a fountain" because the Hebrew word for "fountain" also means "eye." That phrase is inscribed here on the large central hamsa.

The stylized birds and the crescent moons with stars are typical motifs for Hanukkah lamps and other Jewish ceremonial objects from Islamic countries. The tracery line forming the frame of the lamp draws a mosquelike building with a dome supported by five columns, providing an Islamic-influenced counterpart to the phenomenon found elsewhere in Jewish art of creating Hanukkah lamps styled after architecture to symbolize the rededication of the Temple in Jerusalem.

Brass, cast (glass cups missing). 10 ⅞ x 18 in. (27.6 x 45.7 cm). Deinard Collection. Smithsonian Institution, Washington, D.C.

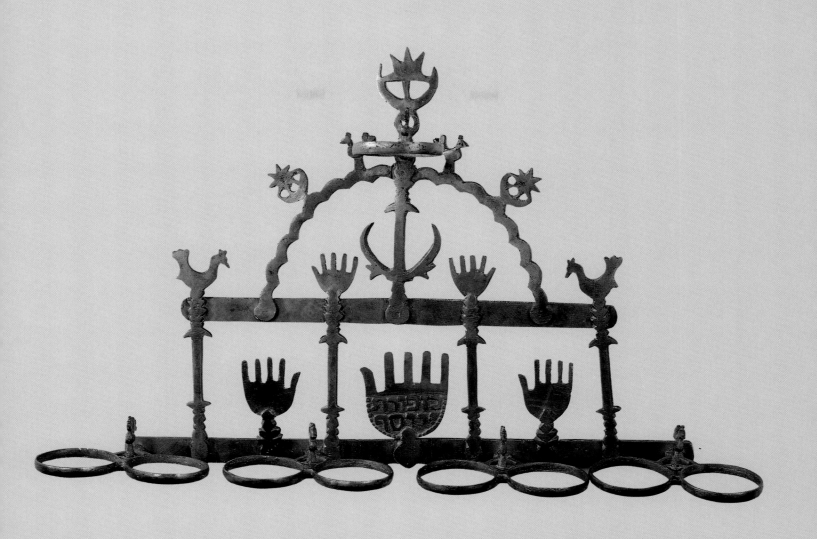

DAMASCENE LAMP

Artist unknown

Damascus, Syria, 19th century

For many hundreds of years, Damascus Jews were skilled metalworkers, fabricating domestic and other decorative arts for themselves and for the rest of the city's population. They perfected a unique and beautiful art form called Damascene ware, which utilizes an inlay technique of yellow copper, brass, and silver. Among the objects typically made in this technique are trays, tables, boxes, goblets, beakers, vases, jugs, coffeepots, knives, and other functional items.

Typically the surfaces of Damascene objects are extensively decorated with cursive lines, calligraphy, roundels, symbols, imagery, and geometric patterns in what is termed the *horror vacuii* (no empty surface) style of Islamic painting, book arts, and architecture. Similarly, Jewish ritual objects in the Damascene technique are embellished with patterns, an infinite curving line, elongated Hebrew letters evocative of particular mannered styles of Arabic lettering, and in some cases biblical scenes and Jewish symbols and personalities.

This nineteenth-century bench-type Hanukkah lamp is composed with clarity and power. The flattened horizontal arched backplate with its openwork crown incorporates stylistic features borrowed from the Islamic world. The border band of Hebrew lettering accentuates the outline of the lamp. The various bands, which feature Hanukkah prayers, are equally decorative and symbolic motifs. The blessings applied in silver enhance the ritual function. The six-pointed Star of David is applied to repoussé roundels, intensifying the reflected glow from the candles that would be inserted into the holders below.

The biblical symbol of the seven-branched menorah is used in Hanukkiot from the Middle East, just as it is in lamps from Western and Eastern Europe. The Lions of Judah protect the ark, here in the shape of the Ten Commandments. The continued use of these symbols for thousands of years in disparate ethnic Jewish communities is a measure of the Jewish ability to retain the beliefs and traditions of Judaism while living in many places throughout the Eastern and Western worlds.

Brass with copper and silver inlay. 11 ½ x 13 ¼ x 2 ¼ in. (29.2 x 33.7 x 5.7 cm). Judaica Museum of Central Synagogue, New York.

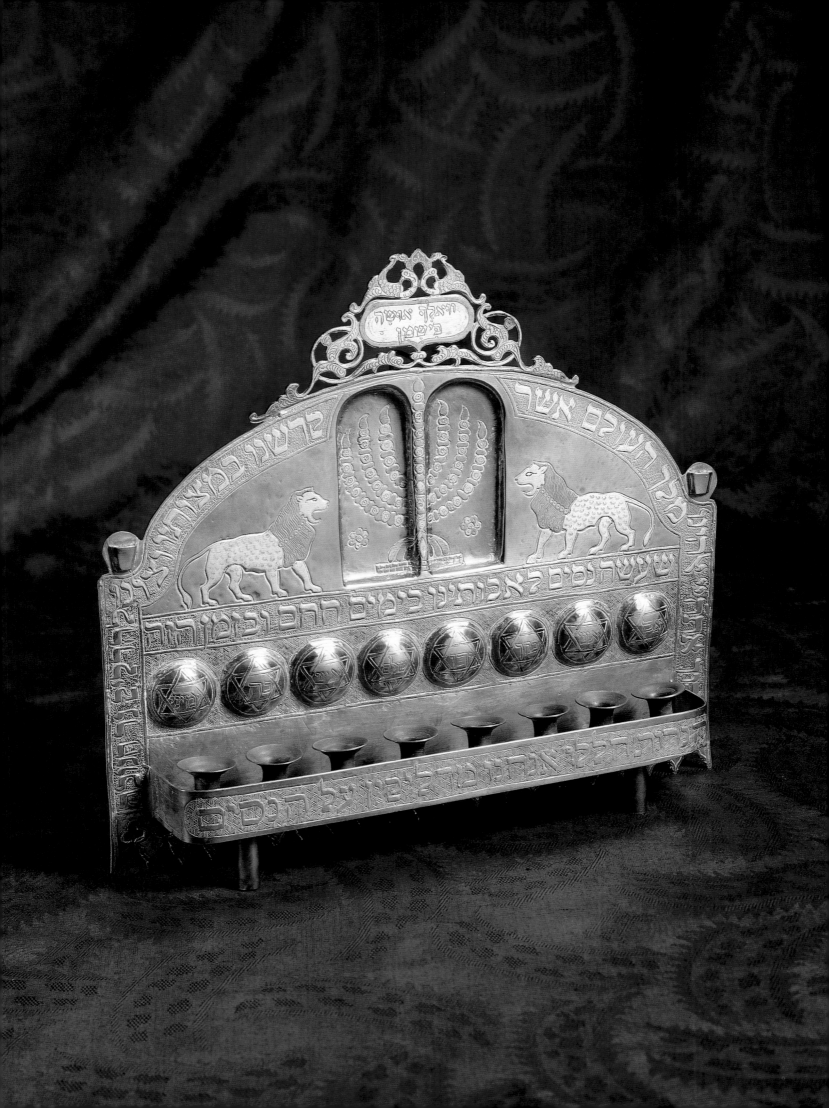

SYNAGOGUE ARK LAMP

Artist unknown
Ukraine, early 19th century

In the New York Jewish Museum's 1985 catalogue of his collection, Jacobo Furman wrote that Jewish ceremonial art objects fascinated him "because of the iconography . . . so strongly linked to the Jewish faith and . . . the profound message they conveyed about the culture of the Jewish people . . . [how they] served the common purpose of fulfilling the Commandments of God in beauty and holiness." This elaborate gold and silver bench-type Hanukkah lamp from the Ukraine, one of the masterpieces of his private collection, embodies each of these characteristics.

Traditional Jewish icons are found on the lamp, such as the Tablets of the Law flanked by rampant Lions of Judah and topped with the crown of Torah. The architectural shape of the lamp makes this part of a group of Eastern European ceremonial lamps that are based on the elaborate carved arks of Eastern European wooden synagogues. Similar to the sophisticated Brody hanging lamp (page 51), there are two stories to the ark, each supported by columns surrounded by balustrades. In both lamps, the ark motifs have swagged drapery, imitating the fabric curtains of synagogue arks. While in the Brody lamp the oil containers are in lion forms, here they are dolphins. Lion paws support the bench of the lamp, reinforcing the use of this kingly animal, so frequently used to signify the tenacity and strength of the Jewish people. A six-pointed Star of David, which in the twentieth century has become widely, if not exclusively, identified with the Jewish people, was seen rarely in the symbolic repertoire of Hanukkah lamps prior to the nineteenth century. Its presence in the very center of the ark in this lamp testifies to its elevation as a more popular and more universally understood Jewish image at the time.

Pomegranate trees gracefully emerge from the sides of the lamp, giving it a lyrical and open outline that complements the densely decorated surface of the piece. The biblical command to create objects of beauty for worship is justly represented in the careful artistry that was brought to the creation of this lamp.

Silver, cast, gilt, engraved, chased, cut out, repoussé, and appliqué; marks: 12 in rectangle; fish-shaped field with interior dots.
20 1/4 x 15 13/16 x 6 7/8 in. (51.5 x 40.2 x 17.5 cm). Collection of Jacobo Furman.

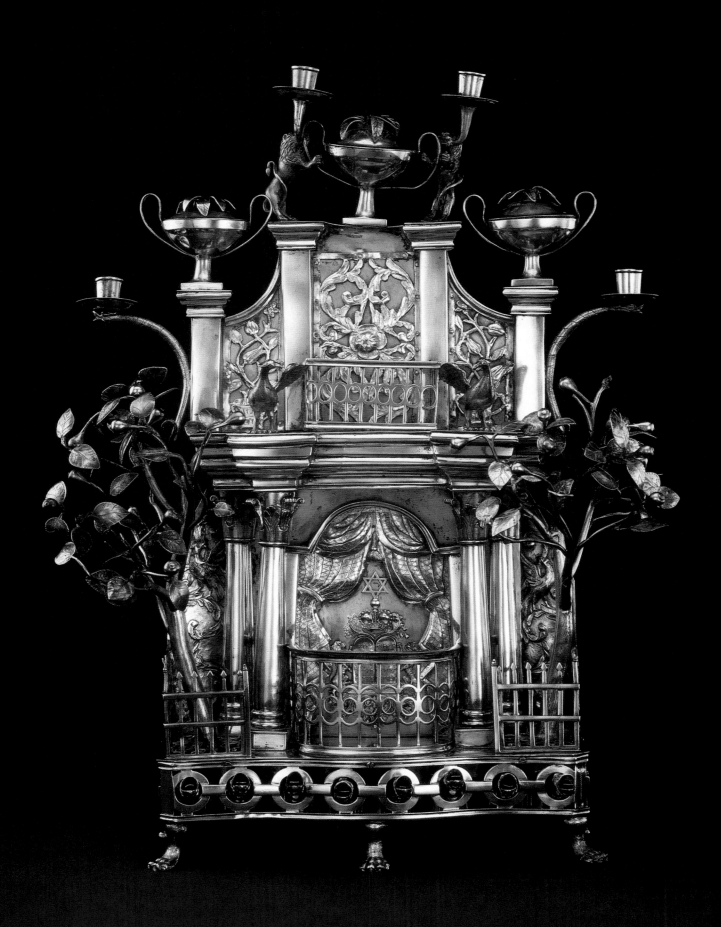

MINTZ COLLECTION LAMP

Artist unknown

Eastern Europe, 19th century

This Hanukkah lamp, a majestic fantasy of the animal kingdom and the Garden of Eden, is a sculptural celebration of art in the service of ritual. The dramatic presence of the work is a result of its monumental size, its artistic quality, and its obvious delight in all forms of natural life. Four dolphins sinuously support a double-tiered stagelike structure, and two sturdy elephants bear the actual Hanukkah lamp. Two elegant lions rest in front of the traditional eight candleholders. Birds, deer, griffins, and even a gorilla and a bear are interwoven with foliage, flowers, tendrils, and palm trees, creating an exotic paradise symbolic of the harmony and peace the Maccabees fought so hard to ensure.

The Jewish Museum in New York became the repository for this unique Judaica object, which, along with four hundred others, is part of the Rose and Benjamin Mintz Collection. The Mintzes, who had been dealers in antiquities in Poland, brought their collection of Eastern European folk art to New York in 1939, ostensibly to exhibit it at the Palestine Pavilion at the New York World's Fair, though the items were never put on display because they were not products of Palestine. When the Nazis conquered Poland later that year, the Mintzes and their collection remained in America, and eventually the pieces were sold to the Jewish Theological Seminary and the Jewish Museum.

A striking feature of this lamp is the similarity of the tracery effect to Eastern European papercuts. The symmetrical nature of the composition reinforces this interpretation. The sculptural forms of the cast animal figures have an artistic vitality and verisimilitude that give the lamp extraordinary life and energy. Against this compelling naturalistic background, the act of lighting the Hanukkah lights takes on a sense of importance as well as a measure of spirituality rooted in a faith in the wonder of creation. Both the gorilla and the bear stand strong upon upright tree trunks on either side of the lamp, as if sentinels on watch guarding Hanukkah's precious light of freedom.

Bronze, cast. 29 ¾ x 26 ½ x 13 ¾ in. (75.5 x 67.3 x 34.9 cm).
Rose and Benjamin Mintz Collection, M446. The Jewish Museum, New York.

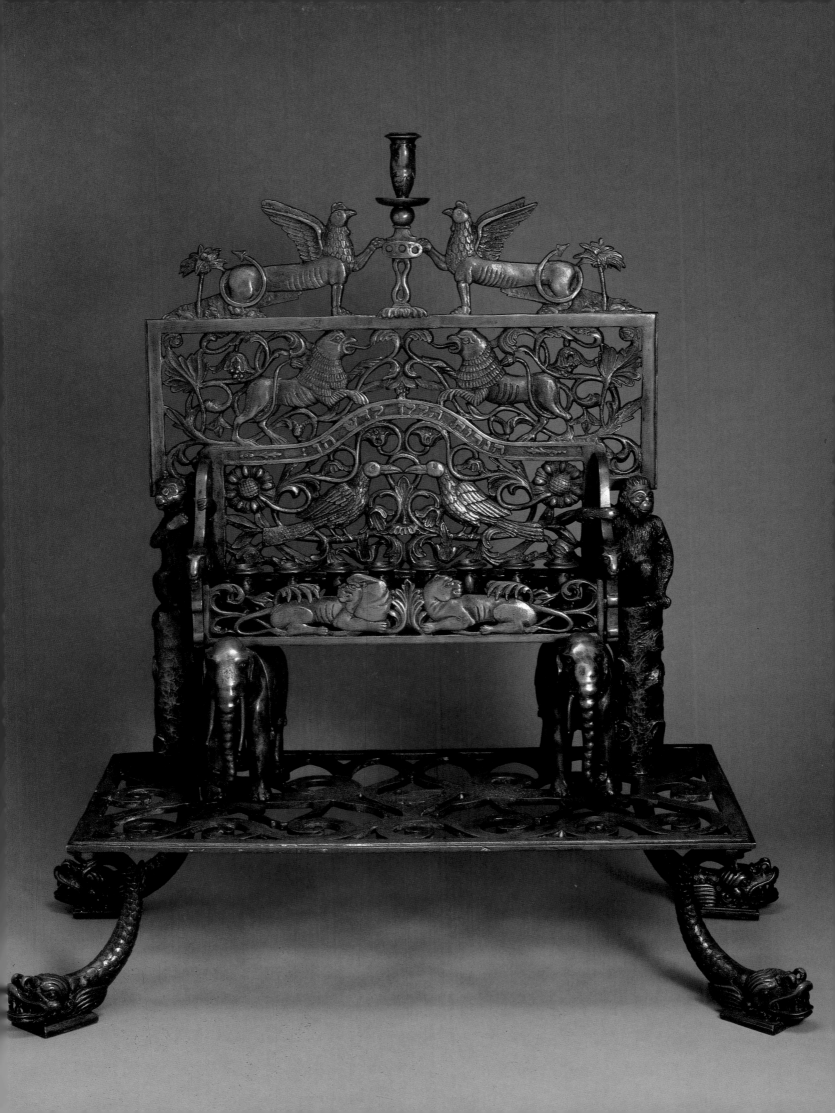

YEMINI LAMP

Yehia Yemini, according to a design by Ze'ev Raban
Jerusalem, 1920s

This Hanukkah lamp is a product of the art movement created in early-twentieth-century Palestine as part of the ideology of cultural Zionism. The Bezalel Art School was born at the Seventh Zionist Congress in Basel in 1905 as a result of an earlier meeting between Theodor Herzl and Boris Schatz; the school was officially founded by Schatz in Jerusalem in 1906. The development of Jewish art in Israel was intended to promote the unification of the various returning Jewish peoples into one Jewish nation as well as to be a means of educating Jews about their past. A self-consciously new "Hebrew" style of art would emerge based on a strict set of imposed criteria that emphasized Jewish and Zionist symbols, the land itself, Zionist figures, biblical subjects, ethnic types, and the pioneering life in the land of Israel.

Among the nearly thirty departments of Bezalel (which included brass casting, lithography, carpet weaving, lace work, and ivory miniatures) was the silver department, where Yehia Yemini, an artist skilled in filigree work, fashioned with exquisite workmanship many of the new designs for ceremonial art that became characteristic of the Bezalel or "Hebrew" style. Ze'ev Raban, a European-trained artist, taught in many departments, including painting, molding, repoussé, and decoration. It was Raban, more than

anyone else, who was responsible for most of the commercial product designs that came out of the Bezalel School after 1914, including the box for the familiar Menora brand of Hanukkah candles, an adaptation of which is still utilized today.

This lamp is a result of the collaboration of these two pioneering fine artists, whose partnership created the marriage of Oriental and Western traditions so idealized in the Bezalel manifesto. As in many artistic renderings of the biblical description of the Temple menorah, the lamp's branches have an alternating knop design. In the synthesis Bezalel was striving for, this design was brought together with the traditional filigree techniques from Yemen that Yemini had brought with him, which he restylized and adapted in his work in Israel. In turn, Raban incorporated these elements into his overall design aesthetic, which was influenced by Western fin-de-siècle art currents.

This work of ritual art has a regal presence because of its balanced proportions and its sophisticated use of colorful semiprecious stones and enamel. On the base, two Lions of Judah flank a vase, which alludes to the miracle of the oil of Hanukkah. This fulfills the agenda of the new Jewish art, in which the eternal symbols of Jewish heritage play a role in the new nationalistic goals of the Zionist movement.

Above: *Box of Menora brand Hanukkah candles (box design by Ze'ev Raban).*
Right: *Silver, semiprecious stones, enamel, marble. 19 x 14 in. (48 x 36 cm). Caspi Collection, Israel.*

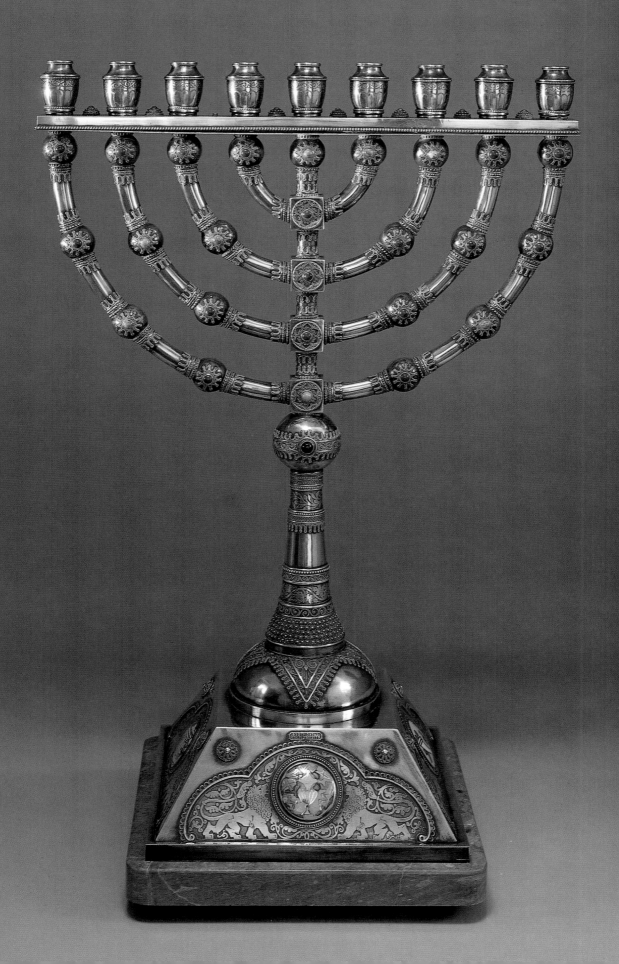

JUDAH THE MACCABEE LAMP

Benno Elkan

London, England, 1946–1956

Benno Elkan created a Hanukkah lamp unique in the profound sculptural drama that decorates it. With fully dimensional figures cast in bronze arranged in a classical composition, the epic tale of Judah the Maccabee is told. At the top of the lamp, a powerful and muscular Judah stands victorious. On either side are his brothers, Jonathan depicted as a philosopher with his head resting on his hand in the traditional pose of deep contemplation and Simeon as a king in medieval English garb. The two figures draped along the bottom are Judah's two brothers who died in the battle against the Syrians, Eliezer and Jochanan. The figure on the right lies fallen and wounded while the brother on the left attempts to escape his inevitable fate. The sculptural arrangement is in the tradition of the triangular format often seen in the facades of European Romanesque and Gothic cathedrals.

The Hebrew inscription at the point where the pedestal and the plane for the Hanukkah lights meet is the biblical verse "Who is like You, O Lord, among the mighty" (Exodus 15:11). The words emphasize God's miraculous power, which brought victory to the brave Maccabees and their followers. However, an equally significant message in this lamp is the poignancy of the sacrifice of Jewish blood to achieve the freedom the Jews demanded from their Syrian oppressors.

Elkan was an important German sculptor who fled Germany in 1933 and took up residence in England. Among the large-scale public sculptures he had done in Germany before he escaped was a seventeen-foot-high freedom monument for the city of Mainz as well as a memorial to the victims of war in Frankfurt. (The latter was removed in 1933 and restored in 1946.) These works provide a context for Elkan's focus on the ravages of war as the price of freedom.

In his later career in England, Elkan made large-scale bronze candelabras in which the branches are adorned with groups of biblical figures. These are in King's College Chapel in Cambridge and New College in Oxford. The most well known of this type in England, however, are the two similar candelabras in Westminster Abbey, each of which has twenty-four groupings of biblical figures from the Hebrew and Christian Bibles. In 1956 the British Parliament presented Elkan's large bronze menorah to the Knesset, the Israeli Parliament. He had worked for over ten years in London on its creation. It depicts personalities and events in the four-thousand-year history of the Jewish people.

Bronze, cast. 26 ¼ x 31 in. (66.7 x 78.7 cm). Spertus Museum, Chicago.

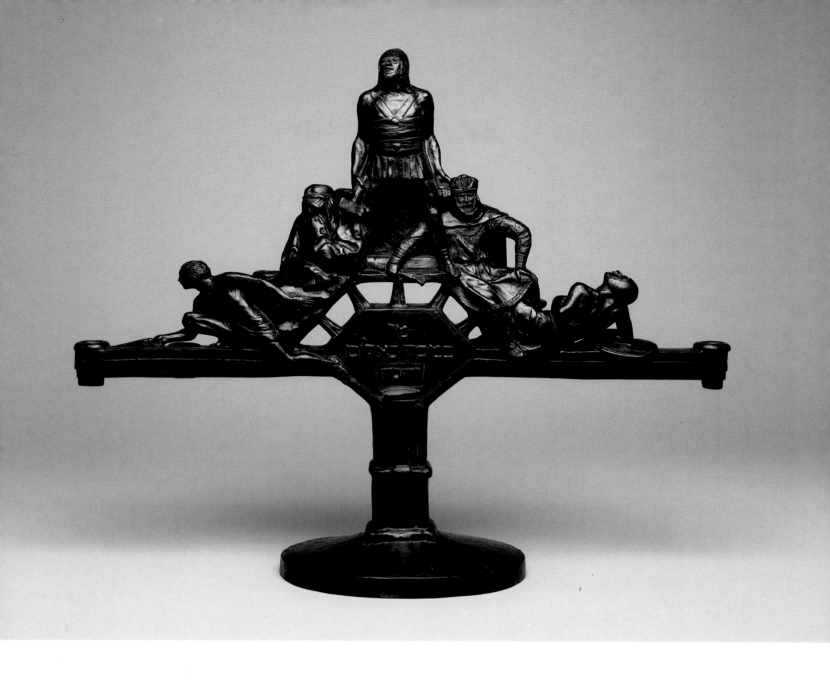

STATUE OF LIBERTY LAMP

Manfred Anson

Bergenfield, New Jersey, 1986

anfred Anson escaped Nazi Germany and found safe refuge in Australia before eventually immigrating to America. In his deeply passionate interpretation of the meaning of Hanukkah, he has conceived a lamp that equates the ancient victory of the Maccabees over their oppressors with the modern democratic ideals of America, in which the Constitution promises religious freedom for all the nation's people. This lamp's potent message is that America's fundamental egalitarian principles, similar to those for which the Maccabees stood, must be upheld as an exemplar in order to prevent repression from repeating itself in the future.

The patriotic use of the Statue of Liberty in this Hanukkiah (in fact, this lamp's Statue of Liberty candleholders were cast from an original nineteenth-century souvenir in Anson's own collection) is a modernization of an age-old practice in which Jewish ceremonial art incorporated national emblems or even images of governmental rulers. This is similar to the inclusion in Jewish liturgy of prayers for national leaders upon whom Jews depended for fair or benign treatment.

As a work of "outsider" or folk art, this expressive lamp combines what appear to be found objects, each of which has been cleverly adapted from its original purpose. The brass Hanukkah lamp is actually a cast of a century-old Polish seven-branched menorah to which Anson added the two outside arms as well as the service light in the front. The Miss Liberty statuettes have been modified so that the torches hold the Hanukkah candles, reinforcing the analogy of the torch of freedom and Hanukkah's allusion to the light of life. The confluence of two cultural heritages symbolized in this lamp represents the life experiences and feelings of many Jewish immigrants to America and reflects a deep faith in the vitality of both American Jewry and American society in general.

Alluding to the many moments in Jewish history when freedom triumphed over adversity are the inscriptions, dated by the artist, under each of the statuettes. From right to left, they are: Exodus from Egypt; Babylonian Exile 597–538 B.C.E.; Judah Maccabee 168 B.C.E.; 2 Revolts Against Rome 60–79 C.E.; 132–135 C.E.; Galut, Herzl Zionist Congress Basel; Holocaust 1939–1945; Israel 1948; and, under the shammash figurine, 1886–1986, dates commemorating the centennial of the Statue of Liberty.

Brass, cast, engraved. 23 x 16 ½ x 7 (diam. base) in. (58.4 x 41.9 x 17.8 (diam. base) cm). HUC 27.154.
Engraved signature on back of shammash statue. Hebrew Union College Collection. Skirball Museum. Skirball Cultural Center, Los Angeles.
Museum purchase with Project Americana acquisition funds provided by Peachy and Mark Levy.

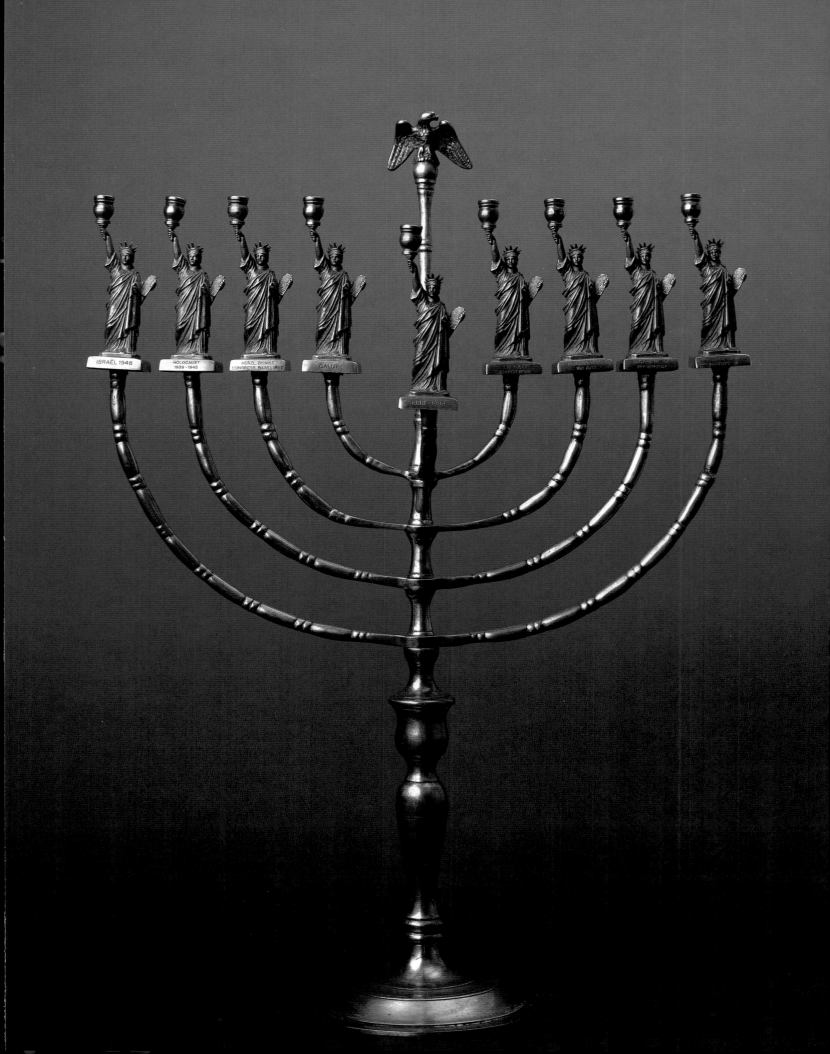

We Kindle These Lights

Ben Shahn

Hightstown, New Jersey, 1961

Ben Shahn was an important American social realist artist. During his long and active career, he was an eloquent and passionate spokesman against injustice, oppression, and poverty. He was the champion of the disenfranchised, the victimized, and the unfortunate. His prodigious artistic facility in diverse media such as paintings, drawings, graphics, photographs, posters, and murals provided multiple opportunities for him to express his strong views on social justice and human rights. The Dreyfus case, the Sacco and Vanzetti trial, Depression-era realities, Nazi brutality, the effects of the hydrogen bomb, civil rights demonstrations—these were what mattered to him, and it showed in his art.

Shahn was born in Kovno, Lithuania in 1898 and immigrated at the age of eight to America. His family was steeped in Jewish learning and custom, which he acknowledged as being a source for his social and political views as well as for the language of his art. He once compared himself to the Jewish mystic Rabbi Abulafia: "I learned first of all the Hebrew alphabet. Like him, I loved to draw and contemplate the big flowing letters." As important as his profound appreciation for the essence and nuance of lettering in both Hebrew and English was his learning and love of Jewish history and values. These ancient and eternal beliefs informed his empathic understanding of the contemporary world just as their artistic expressions became metaphors for his views.

We Kindle These Lights is one of his works with Jewish themes, which he turned to for expressive subject matter many times throughout his career. There is a quality of glory and reverence in Shahn's vision of the seven-branched Temple menorah, fashioned of multicolored prisms that achieve a stained-glass-window effect. The work is a modern equivalent of what he termed the "religious ecstasy" of beautifully ornamented medieval manuscripts. Following an old Jewish artistic tradition, Shahn chose the icon of the Temple's seven-branched menorah because it was the one lit in the Temple by Judah the Maccabee at its rededication.

The Hanukkah blessings over the kindling of the lights are calligraphed in English in a style both reverent and uplifting and are placed at either side of the menorah, as if to give it protection and support. The menorah's exultant branches are a vital part of the message of blessing and praise that Jews assert in this prayer of thanks for the wonders God provided for them. Word and image bring together the force of Hanukkah's ancient meaning of freedom with the relevance that is a necessity for today's world.

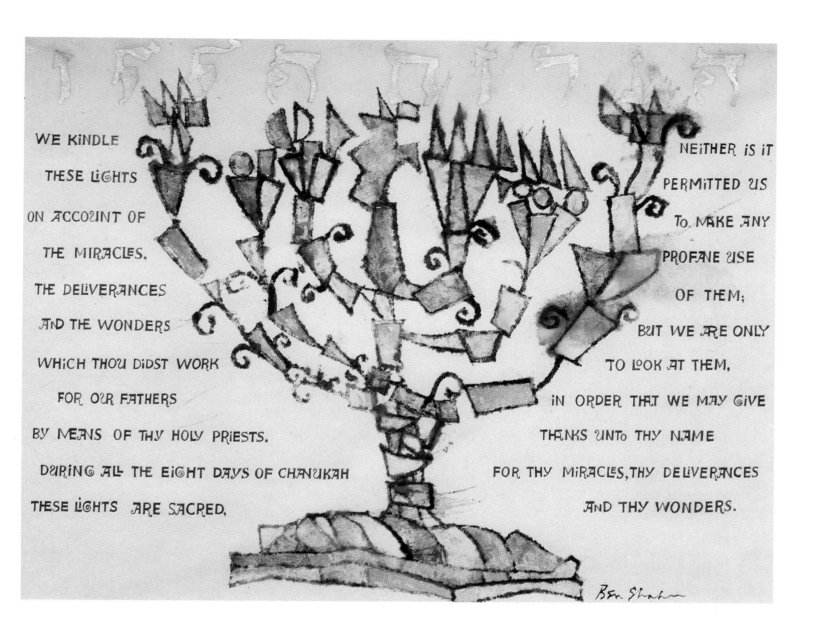

WE KINDLE
THESE LIGHTS
ON ACCOUNT OF
THE MIRACLES,
THE DELIVERANCES
AND THE WONDERS
WHICH THOU DIDST WORK
FOR OUR FATHERS
BY MEANS OF THY HOLY PRIESTS.
DURING ALL THE EIGHT DAYS OF CHANUKAH
THESE LIGHTS ARE SACRED,

NEITHER IS IT
PERMITTED US
TO MAKE ANY
PROFANE USE
OF THEM;
BUT WE ARE ONLY
TO LOOK AT THEM,
IN ORDER THAT WE MAY GIVE
THANKS UNTO THY NAME
FOR THY MIRACLES, THY DELIVERANCES
AND THY WONDERS.

Ben Shahn

MASADA LAMP

Moshe Zabari

New York, New York, 1967

This unique and compelling Hanukkah menorah radically reinterprets the more traditional symbols and associations typically found on Hanukkah lamps. Moshe Zabari is an artist who has dedicated his entire career to the design and fabrication of Jewish ceremonial art. He is truly a *melekhet mahshevet*, a biblical expression for "skillful workmanship" which has come to mean in Hebrew "maker of Jewish ceremonial art." As a contemporary artist, Zabari develops new aesthetic and symbolic ways to characterize the traditional essence of an object of ritual significance.

In this case, he has given a new interpretation of the symbolic content of the lamp. The clearly defined mountaintop shape emerging from an undulating plane evocative of a low, hilly range symbolizes Masada, the mountain rising from the Dead Sea, which has played such a momentous role in over two thousand years of Israel's history. The artist has linked the triumph through martyrdom of the Jewish zealots at Masada in 73 C.E.

with the victory of Judah the Maccabee over the Syrians in 165 B.C.E. Both events signify the Jewish refusal to capitulate to mighty oppressors even upon the threat of death. The story of Masada grew in its importance to modern Israelis and Jews all over the world in the mid-twentieth century, becoming an emotionally charged symbol for Jewish resistance in the years after the Holocaust and in the era of modern Israeli statehood. Because of this, the analogy of Masada and Hanukkah is clearly understandable and represents a modern innovation and addition to the iconography of Hanukkah.

The formal qualities of this lamp express the spirit of Hanukkah in an effective modern artistic vocabulary. The surface and structure of this lamp are totally undifferentiated. The bent and hammered sheet of silver works in several ways to enhance the alliance of ritual and meaning. Its irregular curves and turns imitate Masada's landscape, just as the variously reflecting, shining silver surfaces provide a luminosity and energy analogous to the fire of the Festival of Lights itself.

Silver, fabricated and embossed; in three parts. 6 ¾ x 11 ¾ in. (17.1 x 29.3 cm). HUC 27.121. Hebrew Union College Collection. Skirball Museum. Skirball Cultural Center, Los Angeles. Gift of Lucy Hubbard in honor of Jack H. Skirball.

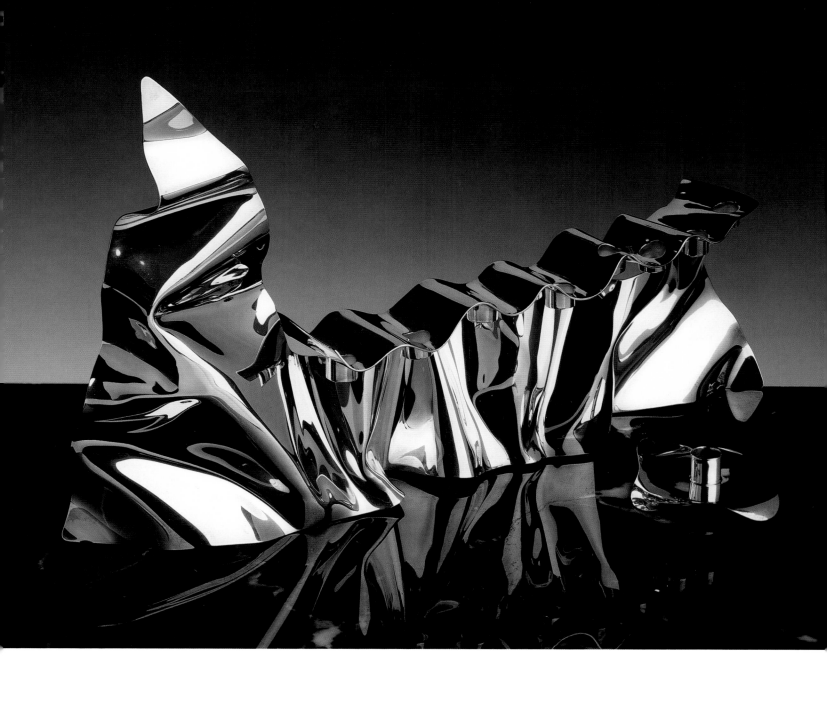

NATZLER LAMP

Otto Natzler

Los Angeles, California, 1985

This Hanukkah lamp has a solid simplicity and proud spirit evocative of the significant historical triumph Jews celebrate on the holiday. The form, beyond its interpretive nature, emerges from the artistic movement of modernism in quiet collaboration with the timeless medium of high-fire glazed ceramics. Its pure geometry and fine proportions resonate with the minimalism that came out of the early-twentieth-century revolution in the European approach to art and architecture. Natzler and his wife, Gertrud, emigrated to America in 1939, escaping Nazi-ruled Vienna, the place where they were born, married, and began the four decades of collaboration that would place them among the great ceramists of this century.

As their joint artistic career progressed, Gertrud became a master of the wheel-thrown shape, and Otto developed ceramic glazing to a high modern art. After his wife's death, Otto began to make hand-built slabs and thereby found a new sculptural direction in his work.

This lamp comes from that period, and its monolithic solidity and symmetry invest the object with a serious sense of purpose. The mystery of its subtle and ever-changing glazed surface, however, adds to the spiritual quality of the lamp's ritual function.

Natzler's work has a purist integrity that is always devoid of any extraneous decorative or symbolic elements. In fashioning this lamp, Natzler laid string on the wet clay to create the spirals that are emblazoned across its surface. Ironically, this design is reminiscent of the Ionic capitals of the classic Greek and Roman architecture so omnipresent in ancient Israel at the time of the Maccabean revolt against Antiochus. A blood-red glaze seems to flow down from the candleholders, as if in reference to the casualties that were the painful price for victory. The quietude and purity of the celadon that covers most of the surface gives the lamp a peacefulness and strength that express hope for the continued vitality of the Jewish people.

Ceramic, celadon reduction glaze with sang and orange. 13 ½ x 18 x 1 ¾ in. (34.3 x 45.7 x 4.4 cm).
HUC 27.134. Hebrew Union College Collection. Skirball Museum. Skirball Cultural Center, Los Angeles.
Museum purchase with funds from the Audrey and Arthur N. Greenberg Acquisition Fund.

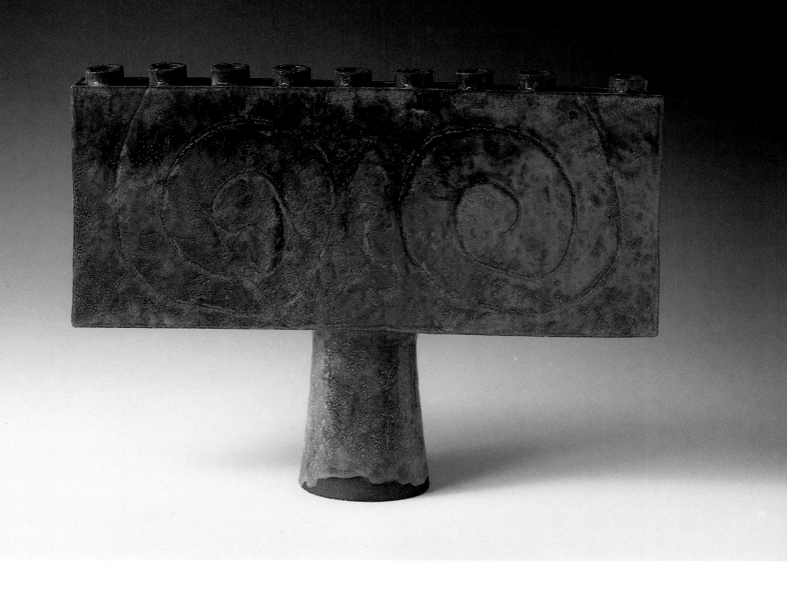

MEIER LAMP

Richard Meier

New York, New York. Designed 1985, fabricated 1990

Contemporary architect Richard Meier created this Hanukkah lamp for the exhibition "Nerot Mitzvah" ("The Lights of Jewish Ritual"), organized by the Israel Museum in Jerusalem in 1985. Nearly twenty international architects, industrial and graphic designers, and ceremonial artists were invited to make prototypes for new forms of Jewish ceremonial lights. The only criterion was adherence to traditional Jewish law as it pertained to any of the ritual objects.

Meier's lamp commemorates the long sweep of Jewish history in its colonnade of architectonic candleholders. Each holder is identified with the style of a place and time where Jews either thrived or suffered persecution and expulsion. From left to right: Egypt; Rome (Hadrian's Victory Column); England, 1290; France, 1310; Spain, 1492; Vienna, 1890; Russia; and Germany, 1933.

Using the familiar language of architecture, Richard Meier's lamp is a modern visual commentary on the eternal relevance of the Maccabee story and the ritual kindling of the Hanukkah lights. The imperative to resist repressive leadership needs to be learned by every generation in order to preserve human values and the ideals of peace and harmony embodied in the Torah.

Richard Meier is a proponent of minimalism, and it is this clear and rational style that has informed his major architectural commissions, including the High Museum in Atlanta, the Museum for Decorative Arts in Frankfurt am Main, and the Getty Center in Los Angeles (to open in 1997). This lamp, with its melange of historical styles, has the self-conscious wit of postmodernism. However, it is not stylistic concerns and conceits that animate this lamp. The lamp's aesthetic power is motivated by over four thousand years of Jewish experience, which is simply and effectively communicated. Rising high above the holy lights (which are in an even row, as prescribed by the Halakah), the shammash towers in a perfect geometry, reflecting the ideals of the future in the universal "world to come."

Tin. 12 ¼ x 13 ¾ x 2 in. (31.1 x 34.9 x 5.1 cm). HUC 27.168. Hebrew Union College Collection. Skirball Museum. Skirball Cultural Center, Los Angeles. Museum purchase with funds provided by the Audrey and Arthur N. Greenberg Acquisition Fund.

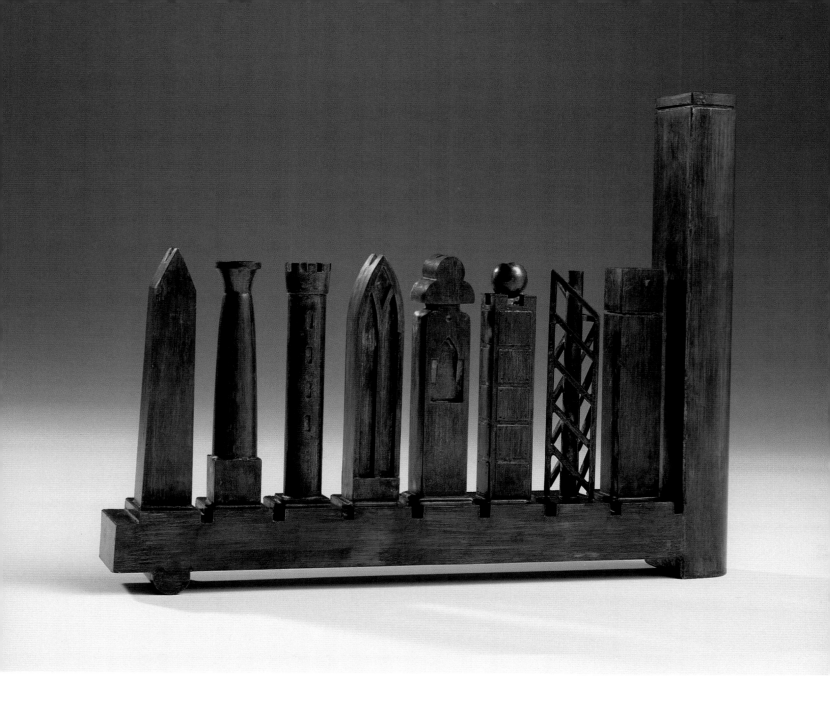

LOS ANGELES LAMP

Peter Shire

Los Angeles, California, 1986

This Hanukkah lamp was the first piece of Jewish ritual art that Peter Shire, world-renowned sculptor, ceramist, and furniture designer, ever created. In the mid-1980s, Shire researched the Skirball Museum's vast collection of Hanukkah lamps, which included many reflecting the periods and places from which they came. As a result, he produced eight large-scale, hand-wrought, innovative Hanukkah lamps that extended the Jewish ceremonial art form into the postmodern era.

Shire was active in Memphis, the contemporary Italian design movement of the 1980s, which rejected the clean, spare, nondecorative, functional aesthetic of the postwar years. In this lamp emerges Shire's notion of art, based on a sense of adventure and play conveyed through bold color, form, and pattern statements. Elements of fantasy, ephemera, and the transience of life and art are also evident in this lamp.

Shire calls this a California Hanukkah lamp because "it is about the Jewish people who live there." The piece exudes free-form design, style, architecture, humor, and the diverse and casual character of life in Los Angeles. Its geometry of shapes and their brilliant and pastel colors reflect the spirit of Spanish-style bungalows, Pacific beaches, and jagged street patterns; it also contains allusions to the metallic prevalence of the automobile and motorcycle in the urban southern California landscape. The interplay between the adventuresome wit and the poetic spirituality of this elegant design makes it a masterful work. The machine aesthetic of this piece belies its carefully hand-crafted origin. As a work of Jewish functional art, this lamp, with its unexpected and nontraditional appearance, is true to the criteria of ancient Jewish sages, who required places for all eight lights to be on a single plane, with the shammash elevated.

Anodized, painted, and chromed steel. 21 x 24 ½ in. (53.3 x 61.5 cm). HUC 27.142. Hebrew Union College Collection. Skirball Museum. Skirball Cultural Center, Los Angeles. Museum purchase with funds from Judy and Marvin Zeidler.

Hanukkah Lamp in Four Levels

Zelig Segal

Jerusalem, Israel, 1984

Zelig Segal's *Hanukkah Lamp in Four Levels* makes the "user-friendly" aspects that all Hanukkah lamps possess even friendlier. Hanukkah lamps are characteristically interactive because the person lighting the lamp is "performing" the ritual with both a physical act and a spiritual purpose. Segal's lamp provides the opportunity for even greater participation, as its design can be created and re-created each night. The four pieces can literally be taken apart and recombined in numerous compositional and artistic formats, depending upon one's mood or preference. Alternatively, the lamp comes with four separate bases, sets of candleholders, and tops so that each piece can be used as a separate lamp, enough for each in a family of four in keeping with this personally inclusive ritual. In the spirit of the miracle of the holiday, one lamp can equal four lamps. Segal's lamp, with its options for re-creation and for sharing, gives added dimension to the Hanukkah celebration. The involvement of humans in the religious experience is played out at an exceedingly experiential level.

Furthermore, the fun of putting together a puzzle-piece menorah is reflective of the game-playing and conviviality of the holiday.

The four levels of this lamp represent the artist's vision of the Jewish nation, which is continually rebuilding itself in order to perpetuate the continuation of the people and the religion. Segal, born and raised in Israel, is a contemporary advocate of the Zionist appreciation for the theme of the Maccabean victory. The courage and strength of both the Maccabees and the Zionists, as well as their struggles against great odds for national freedom, are embodied in the spirit and symbolism of this lamp. The shieldlike shape of the lamp has the force and military spirit of Jewish victors, from Judah the Maccabee to the heroes of the many modern wars Israel has fought.

Zelig Segal holds an important place in the creation of contemporary Jewish ritual art. He has won many prizes, commissions, and awards, and he has participated in exhibitions throughout the world.

Aluminum, laminated, painted, and kiln-fired. 7 ½ x 14 in. (19 x 36 cm). Collection of Mark and Peachy Levy, Los Angeles.

TEMPLE LAMP

Bella Feldman
Oakland, California, 1993

I n the words of the artist herself, "This large and massive menorah is intended to be permanently displayed as both a historical symbol and an evocative sculpture." The simple and strong architectonic forms of this Hanukkiah signify a Temple of monumental power and sacred ritual. The sense of the Temple's centrality and significance to Jews since biblical times is contained in the balanced and formal spiritualized shapes, which conjure up the archetypal place of meeting between God and man in any culture. The shieldlike nature of the larger form, with its sword-blade curve and seemingly insurmountable and protective incline toward the Temple chamber above, adds the connotation of the military force of the Maccabees, who fought to restore religious freedom.

The miracle of the Temple menorah's light burning for eight days when the Maccabees commemorated their victory is the transcendent idea of this work. The shammash, as if a Temple guard or torch, heralds a staircase ascending from some mysterious perch up to the high and holy level, the place of the performance of the ritual of the Hanukkah festival. The spaces for the candles exist behind shutters that are to be kept closed throughout the year. The artist's intention is that on each day of Hanukkah another shutter be opened to reveal the number of candles appropriate to the day, with the closed ones indicating the days of the holiday left to celebrate.

In 1991 Bella Feldman won one of four honorable mentions in the prestigious competition for the Philip and Sylvia Spertus Judaica Prize, sponsored by the Spertus Museum in Chicago. She has explored the theme of ancient Mayan pyramidal architecture in her work as well as that of machines of war transformed into her version of "war toys." Both have contributed to the thematic and symbolic references inherent in this work. However, the distilled spiritual presence of this Hanukkah lamp possesses a dignity of honor and hope for the continued struggle for freedom.

Silver-plated steel. 29 x 35 ¼ x 12 in. (73.7 x 89.5 x 30.5 cm). Collection of Robert and Sandra Carroll.

The Lamp That Burned On

Ginny Ruffner

Seattle, Washington, 1995

The miracle of the Hanukkah story is eloquently conceived in Ginny Ruffner's *The Lamp That Burned On*. The duality of form and function is fully realized in this innovative Hanukkah menorah. Its exotic and supernatural form alludes to Aladdin and his magic lamp. Rubbing the magic lamp brought Aladdin all he could wish for; lighting the Hanukkah lamp recalls God's miraculous answer to the Jewish people's wish for religious freedom. Its light continues to burn on, giving hope for the triumph of light over darkness.

This work was created for "A Hanukkah Menorah Invitational," sponsored by the Jewish Museum, San Francisco. In this exhibition, artists were invited "to create a Hanukkah lamp in their own image." Glass artist and sculptor Ginny Ruffner has work included in the collections of the Metropolitan Museum of Art, the American Craft Museum, and many others, as well as in private collections and public art spaces. Some of her collectors urged her to submit a Hanukkah lamp to the invitational show even though, as she states, "I never make functional objects, particularly religious functional objects, but this project was intriguing." In the past, patronage has been responsible for the design and fabrication of important and inspired Judaica. Ginny Ruffner's creation demonstrates the vitality of this exchange even today.

The artist was inspired to fashion this unique menorah by a friend who recounted the story of the miracle of Hanukkah. Imbuing the lamp with the mystery of the miracle, she wanted to "create a lamp whose lights appear to be on the end of the plumes of smoke coming out of it." Luminescent glass, sparkling gold, and jewel-tone blues further enhance the enchanted shape of the artist's imagination.

This new form, marrying religious tradition, folk literature, and popular culture, fits firmly into the continuum of the art of Hanukkah. As has so often been the case, Jewish art forms are infused with traces of the culture in which they were created, a phenomenon that enlivens and enriches Jewish art and the art of celebration.

Glass and mixed media. 7 ½ x 17 x 8 ½ in. (19 x 43.2 x 20.3 cm). Collection of the Reichman Family.

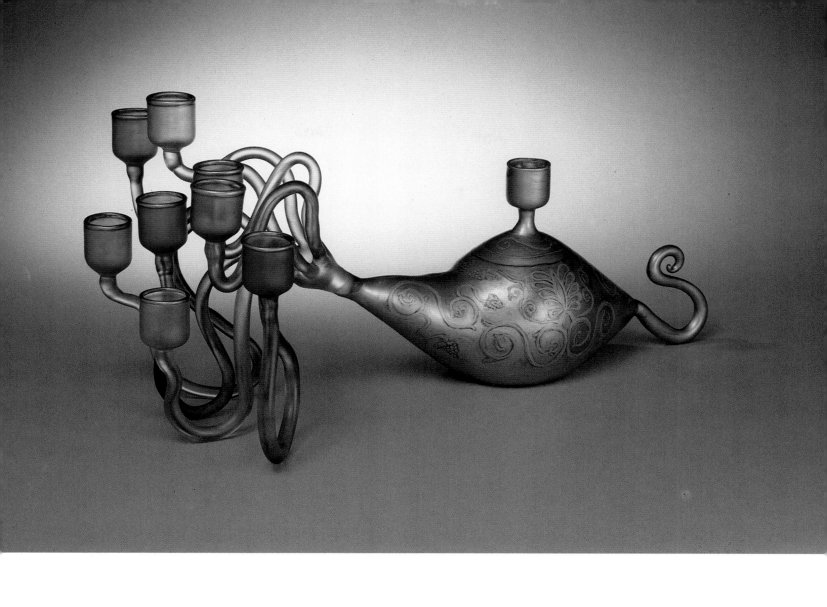

From: *Haneirot Halalu: These Lights Are Holy*

Leonard Baskin

Leeds, Massachusetts, 1989

One of the finest modern American artists, Leonard Baskin was commissioned to create a series of nine original paintings for inclusion in an important contemporary guide for the home celebration of Hanukkah. This liturgy, issued by the Central Conference of American Rabbis, includes blessings, prayers, readings, and songs for each of Hanukkah's eight nights. The book is a modern liberal guide, serving a purpose similar to that found in the traditional literature, such as Maimonides's Mishneh Torah (thirteenth century) or Joseph Karo's Shulhan Arukh (sixteenth century). This contemporary volume combines modern liturgy and modern art, speaking very directly to contemporary Jews in the verbal and visual languages that enliven the ritual and enhance its message for our times.

Leonard Baskin has had a distinguished career as a sculptor, painter, graphic artist, and book designer. Born into a family of rabbis, and rabbinically trained himself, Baskin has delved deeply into biblical and other Jewish sacred texts in the content of his work. He is today's inheritor of a Jewish art and book tradition that began with Jewish illuminated manuscripts from the Middle Ages.

A master of character and attitude in the drawing of human and other natural forms, and an inspired and knowledgeable calligrapher, Baskin has created illustrations that serve as visual midrashim, conveying a deeper understanding of the essence of the Jewish meaning of the festival.

The Second Day is a vivid coloristic and calligraphic interpretation of the Hebrew words of ultimate faith displayed upon the page. The letters near the top rise high, like the meaning of the words they form: "Though I fall, I shall rise." The words "Though I sit in darkness" are buried in a black band across the middle of the painting, and they are somewhat obscured by the burning flames of the menorah, a symbol of the phrase "The Eternal shall be a light to me."

The martyrdom of Hannah and her seven sons is the subject of *The Third Day*. Hannah, with a face of strength and conviction, enfolds her beloved sons as they face death rather than dishonor the Torah and God.

In *The Seventh Day*, Baskin paints "An angel of God! Our Protector," whose appearance on the battlefield gave the Jews the courage to renew and win their battle against their enemy (2 Maccabees 11:8ff.). The angel here is painted as a timeless, light-filled spirit, its divine nature evoked through the soft, evanescent color tones, its strength and majesty radiating from its sheltering wings.

Among other illustrations in the book are a victory painting of the military banners of the Maccabee triumph and a charming depiction of dreidels to be played with at the holiday celebration to remind one of the "great miracle that happened there."

Watercolor. Top left: *The Second Day.* Top right: *The Third Day.* Bottom: *The Seventh Day.* All works, 7 ¼ x 10 ½ in. (18.4 x 27 cm). *Published in Central Conference of American Rabbis (CCAR)*, Haneirot Halalu: These Lights Are Holy. *(New York: CCAR, 1989).*

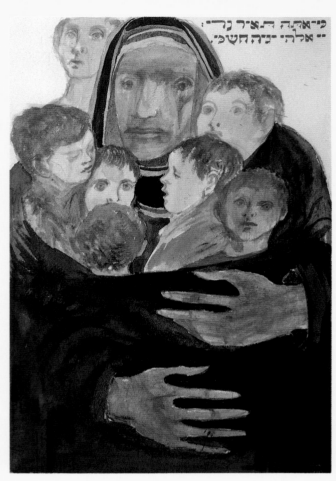

Hanukkah in New York

Malcah Zeldis

New York, New York, 1994

Malcah Zeldis, a self-taught artist, paints to express her personal Jewishness. Childhood memories, favorite Jewish stories, and images of family fill her canvases. Like many folk artists, Zeldis mines her own cultural, religious, and ethnic heritage and experiences as themes for her work. Jewish traditions, life-cycle rituals, and holiday celebrations, as well as Bible stories, provide the artist with ample subjects for her painting.

In *Hanukkah in New York* the artist depicts her apartment in New York City on the final night of Hanukkah. This vivid picture melds a lifetime of Hanukkahs into one complex yet simple image. Year after year, family members gather together in this dining room, at this table, to kindle the Hanukkah lights, sing songs, tell stories, eat latkes, and revel in the joy of celebrating together. With the Hanukkah lamp ablaze, children play dreidel on the floor, while outside the window, the skyline of New York suggests the rest of the world carries on, unnoticed by the Jewish family inside. Jewish rituals are designed to emphasize the distinctness of being Jewish. The enclosed room, with everyone gazing out at the viewer, adds to the effect of separating this Jewish holiday celebration from the rest of the world.

Narrative paintings such as *Hanukkah in New York* are typical of the works of contemporary folk artists. Romanticized memories mingle with objects, people, and images from different times and places. The artist freely and purposely compresses time, putting herself into the painting twice, both as a child and as an adult. Also depicted, from still other times and at varying ages, are her mother, father, children, and grandchildren. Scenes such as this flow from the artist's memory and imagination, full of the spirit of the celebration, the joy of coming together, and the continuity of Jewish observance.

This vivid picture with its bold, flat colors eloquently conveys the artist's thoughts and feelings and tells stories—both the artist's own and those of the Jewish people—in a direct, personal way. For Zeldis, memories come flooding back each time she sits down to paint, as vivid in her mind as they are vibrant on the canvas.

Malcah Zeldis has achieved recognition among American self-taught artists. Her work is in museums throughout the country, including the Smithsonian Institution, and she has had a one-woman show at the Museum of American Folk Art. Her paintings, based on early memories, are idylls of Jewish family celebrations, one artist's nostalgic view of the Festival of Lights.

Oil on board. 24 x 28 in. (61 x 71.1 cm). Collection of the artist.

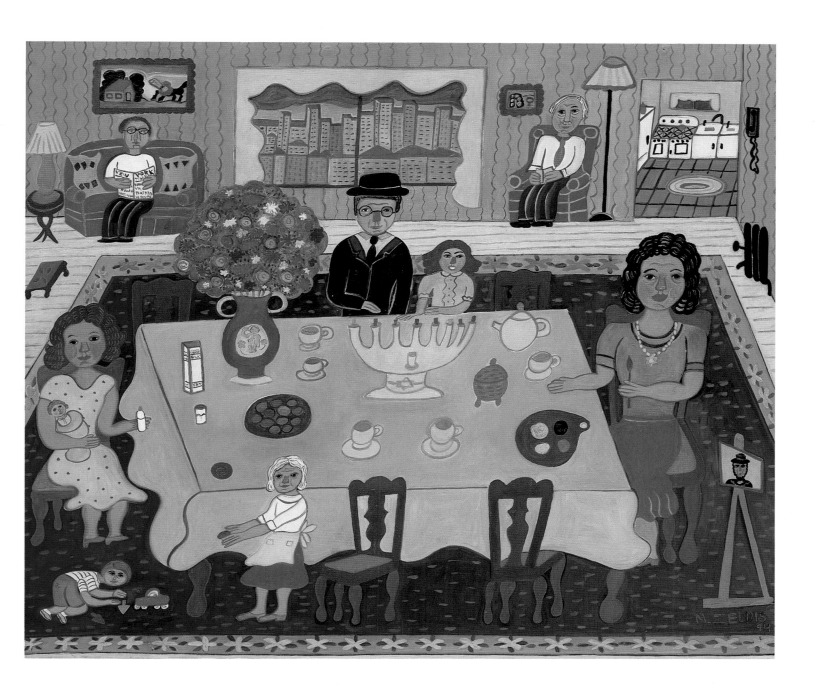

CONTEMPORARY DREIDELS

Various artists
United States and Israel, 1985–1995

Playing dreidel has been a popular Hanukkah tradition since medieval times. Jewish museums throughout the world have collected dreidels made of carved wood and ivory, or cast in lead, silver, pewter, and other metals. In the latter half of the twentieth century, artists were attracted to creating new kinds of dreidels. Similarly, manufacturers of mass-produced commercial holiday products took advantage of a growing market reflective of trends in modern Jewish holiday observance. Both individual artists and commercial designers have conceptualized and fashioned today's dreidels using wood, glass, ceramic, plastic, Plexiglas, liquids, confetti, electronics, and other unusual materials. Even manufacturers of fine china and silver such as Tiffany, Christofle, and Wedgwood have made dreidels of silver, porcelain, and crystal for their clientele.

This selection of charming, colorful, and unusually designed dreidels has been lovingly collected by a family who appreciated them not only for their function but also as reflections of modern Jewish identity and historical circumstance. These dreidels are made of both traditional and contemporary materials. Some of them are to be wound up; they walk instead of spinning. Others light up and play the music of the Hebrew Hanukkah song "Sevivon, Sov, Sov, Sov." Sold widely in Israel today are wooden dreidels with painted miniatures of flowers, country scenes, Hanukkah symbols, and images of Jerusalem; decorated by Russian émigré artists who were skilled painters in their country of birth, these dreidels resemble Russian folk art nesting dolls.

Israeli artist Danny Azouly and American artist Leslie Gattman have created new dreidel shapes and designs out of porcelain and clay. Bonnie Srolovitz has developed an innovative dreidel form that spins on a ball; an original made of brass and silver is in the permanent collection of the Jewish Museum in New York.

Dreidels made in Israel commonly bear the Hebrew letters *nun* (נ), *gimmel* (ג), *heb* (ה), and *peh* (פ), the first letters in the Hebrew words of the phrase "a great miracle happened here," while dreidels made and used outside of Israel have letters standing for the phrase "a great miracle happened there."

As artists and manufacturers continue to create interesting new dreidel designs in innovative materials that express the exuberance, novelty, and joyful feeling of Hanukkah, modern Jews use them not only for fun and games but also as an expression of Jewish identity. Indeed, dreidels express the vitality of the Jewish people—whether created by modern Russian immigrants, a distinguished English china company, a contemporary Jewish artisan, or a commercial designer. As such, they are displayed in the home as a proud and joyful expression of contemporary Judaism. A house full of these charming, humorous, playful symbols not only enhances the *hiddur mitzvah* of the house but also establishes a joy in being Jewish.

Mixed media: lacquer, paint, paper decal, plastic, porcelain, and wood.
All dreidels, approximate height 2–3 in. (5.1–7.6 cm). Collection of Linda and Lennard Thal, Los Angeles.

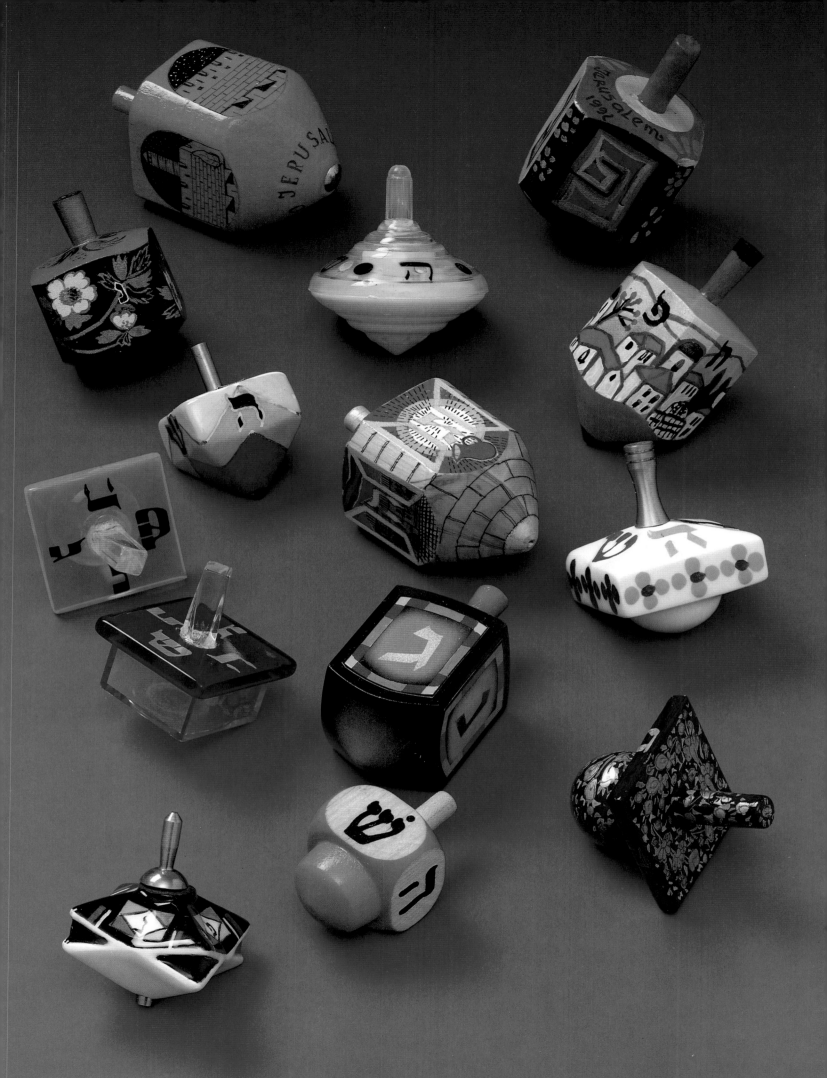

MEANDER LAMP

Kerry Feldman

Breckenridge, Colorado, 1995

Glass artist Kerry Feldman has been making contemporary Judaica for nearly a decade. His initial creations were glass kiddush cups, goblets, and chalices in bold colors and designs, after which he went on to invent a uniquely modern interpretation of a Passover Seder plate now in the permanent collections of the Jewish Museum, New York, and the Skirball Museum, Los Angeles.

Feldman brought to the work he created for the San Francisco Jewish Museum's 1995 Hanukkah menorah invitational exhibition a knowledgeable Jewish background from his family as well as a proven interest in exploring the tradition of Jewish ceremonial art. The form and content challenge for Feldman was how to create an aesthetic work that would also incorporate age-old religious requirements for the ritual Hanukkah lamp. It was important to him to achieve a design that would adhere to rabbinic precepts. As a result, this unmistakably modern Hanukkah lamp has lights in an ordered row and on the same level, with the shammash elevated above the sanctified lights. This classically simple arrangement has numerous precedents throughout Jewish history. The fifteenth-century Rothschild Miscellany manuscript pictorializes a similar eight-branched Hanukkah candleholder, elevated high upon a pedestal.

As an artistic medium, glass is fluid and flexible in its molten state. The soft and undulating shapes of the swaying candleholders belie the rigidity of the material. Their cobalt blue color is bold in its compelling brightness but soft in its transparency. The rose quartz candle receptacles crown the vertical forms in a way that accents the energetic movement of the elements.

No symbolism has been applied to the piece; formal and artistic methods and values take precedence. The Jewish content is in its purely functional nature of having a place for eight lights. Yet a longer concentration on the piece invites a perception of the many subtly produced Jewish interpretations. The candleholders themselves are metaphoric candles; with their flickering whimsical surface decoration created with gold and brightly colored glass pictographs and squiggles, they seem to burn even when unlit. Their rigid formation suggests a full-dress military victory parade, clearly an allusion to the successful rebellion of the Maccabees. The seemingly endless lineup of light forms connotes the continuum of Jewish history and the continuation of the celebration of Hanukkah, now and in the future.

The beauty of the material and its color, the interpretive depth vested in it, and a balance of humor and seriousness have been combined in a lamp with not just a spirit of joy but also the hope, proclaimed in a favorite contemporary Hanukkah song, that Jews "won't let the light go out."

Aluminum, hand-blown glass, and rose quartz. 12 x 20 x 3 in. (30.5 x 7.6 cm). Collection of the artist.

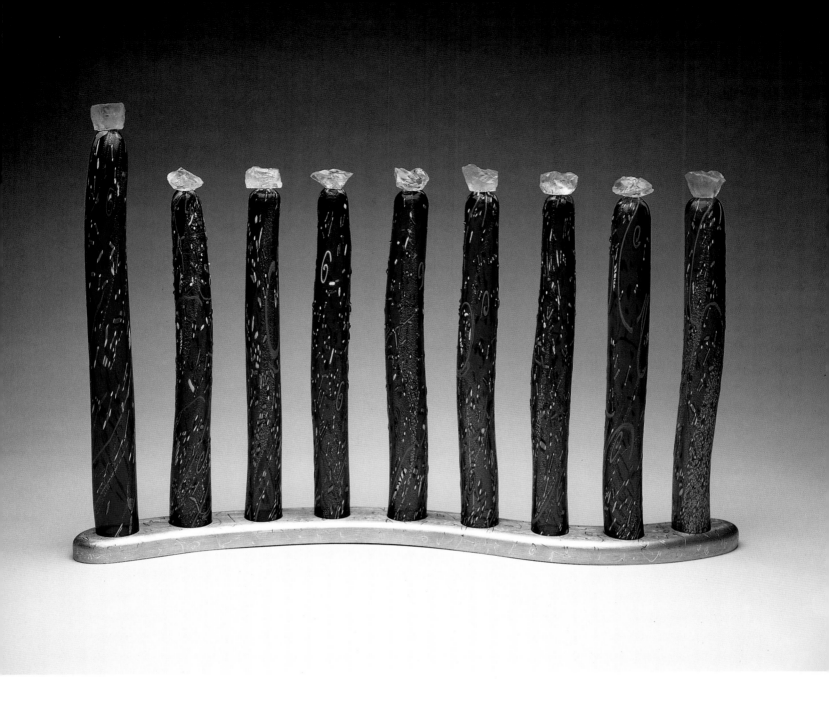

Hanukkah Still Life

Karen Koblitz

Los Angeles, California, 1993

Karen Koblitz's Hanukkah sculpture is one of a series of still lifes she began in the early 1980s. Influenced in her college years by the important Italian Renaissance ceramic artists of the della Robbia family, she developed an affinity for the colors, textures, and fruit and foliage forms found in their works. She infused her work with imagery identified with her own life and times, including this Hanukkah still life, which distills her experiences, perceptions, and feelings of the holiday.

Joy and celebration are reflected in the brightly painted colors, patterns, and textures, which appear to playfully jostle each other in exuberant juxtaposition. The entire composition has the effect of a large Hanukkah present observed at the moment after it was excitedly unwrapped to reveal its many treasures. An elaborately designed Oriental carpet is draped on top of the gift box/tabletop form. The ceramic menorah is a *trompe l'oeil* representation of a real Hanukkah lamp typi-cally found in American Jewish homes in the mid-twentieth century. The lamp exists not as a functional ritual object, but rather as a functional *spiritual* object that evokes Jewish ritual, memory, and experience. The motif of the golden coins and brightly painted ball peeking out behind the flowing tablecloth are relevant to the customs and rituals of Hanukkah, including game playing, a party atmosphere with special sweets, gift giving, and of course lighting the menorah.

Seventeenth-century Dutch still-life painting invoked the transitory nature of life and the inevitability of death. Nineteenth-century French impressionists strove to create in the still life a unique "slice of life" to differentiate one moment from another. In this Hanukkah still life, Koblitz created a visual continuum of over two thousand years of Jewish time. Symbols of biblical heritage intertwined with icons of Jewish objects popular among twentieth-century American Jews represent the collective moments that constitute a living Jewish history.

Low-fire clay and glaze. 18 x 21 x 12 in. (45.7 x 53.3 x30.5 cm). HUC 67.148. Hebrew Union College Collection. Skirball Museum. Skirball Cultural Center, Los Angeles. Purchased with funds from Dr. Arnie Gilberg.

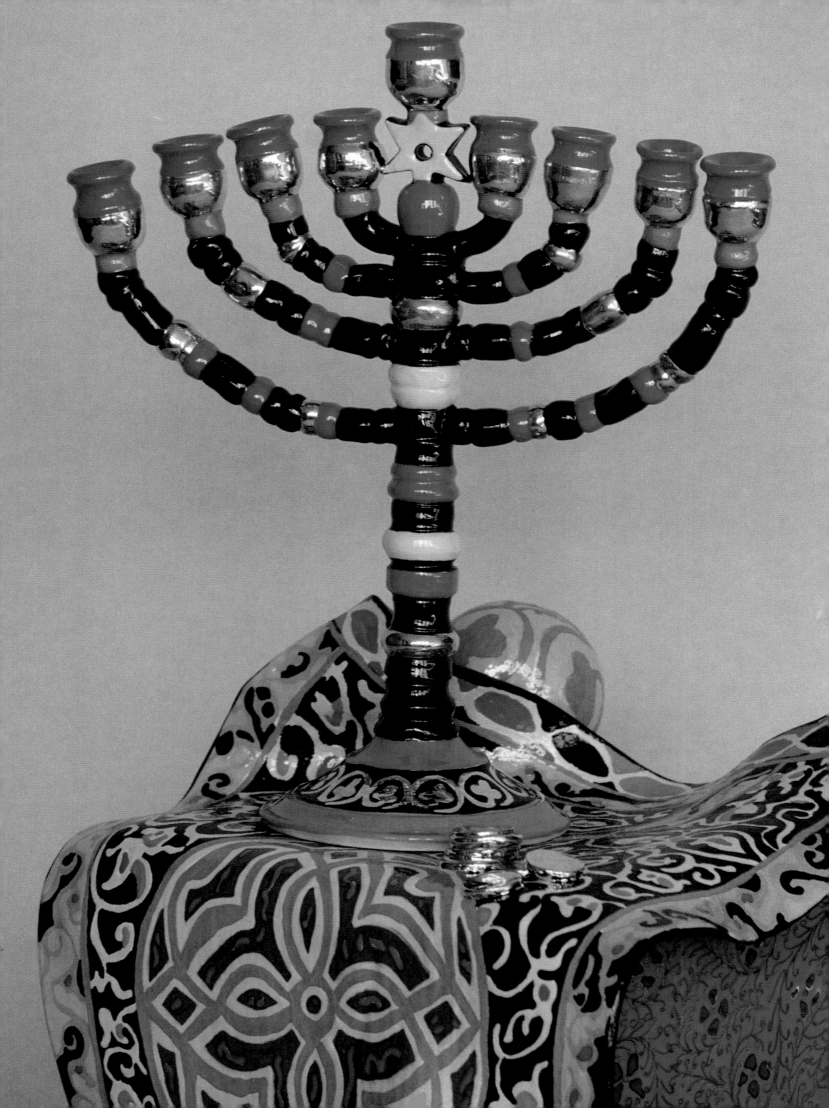

In Days of Old, at This Season
בימים ההם בזמן הזה

Alex and Lorelei Gruss
New York, New York, 1996

Throughout the twentieth century, artists have taken creative liberties and sometimes radically new approaches to the design of the Hanukkah lamp. With this unique ceremonial art object, artists Lorelei and Alex Gruss have added yet another artistic and symbolic shape to the expanding repertoire of menorah forms. Attracted to geometric shapes because of their universal nature as well as the strength they convey, this artist couple has created an inlaid wood pyramid for their Hanukkah lamp. The Kaballah, the thirteenth-century book of Jewish mystical writings, alludes to the pyramid shape as spiritual because it ascends heavenward. It is a well-chosen metaphor for an object that facilitates the ritual candle lighting commemorating a God-given miracle.

This lamp is created from exotic woods, semi-precious metals, and other natural materials, emphasizing their colors and textures. The pyramid is created out of cocobolo and rosewood, and the inlays are of pink ivory, ebony, purpleheart, poplar, snake wood, and walnut as well as copper, silver, brass, abalone, and mother-of-pearl.

This lamp takes full advantage of the Grusses' collaborative style. Generally, Alex Gruss designs the piece, relying heavily on his formal training and background in graphic art, while Lorelei Gruss fabricates each piece, including the inlay and silversmithing, utilizing skills she has perfected since she began her apprenticeship at the age of fifteen in Israel.

The front of the Hanukkah menorah displays the holy Temple in Jerusalem, the sacred locus of the miracle of Hanukkah. A glass window in the bottom door reveals nine silver oil receptacles resting on a tray, which pulls out for the purpose of kindling the lights. The top door, with the inscription "We kindle these lights," opens to reveal an oil pitcher and glass liners for the silver oil receptacles. Two other upright faces of the lamp represent the historic background of the Hanukkah story, with images of Judah the Maccabee and his troops, Hannah and her sons, the menorah from the Temple, and the Syrians. The remaining upright face of the pyramid-shaped menorah depicts scenes from contemporary Jewish life: A child spins a dreidel on the floor while another child offers Hanukkah treats, and a patriarchal figure looks on while a family lights the menorah. All faces of the lamp have luminescent skies made from abalone to enhance the spiritual quality of the ritual.

Cocobolo, rosewood, purpleheart, ebony, poplar, snakewood, walnut, abalone, mother-of-pearl, pink ivory, copper, brass, and sterling silver.
21 x 17 x 17 in. (53.3 x 43 x 43 cm). Collection of the artists.

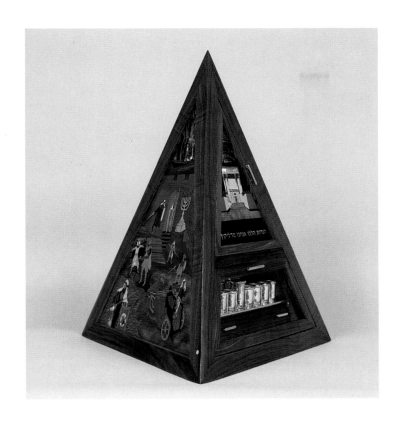
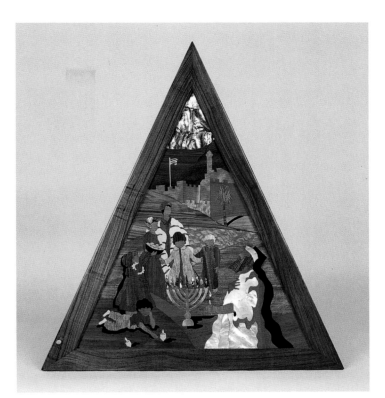
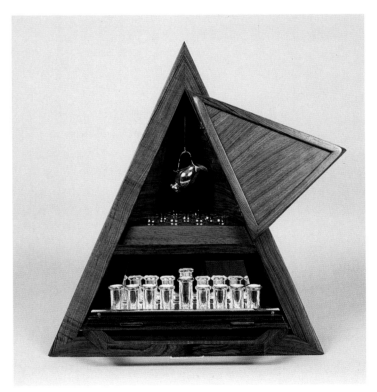
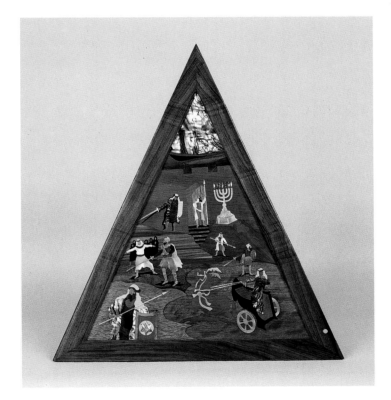

Menorah and Magnolias

Bill Aron

Los Angeles, California, 1988

American photographer Bill Aron is best known for his photographic essays of Jewish communities throughout the world, including ones in Cuba, Turkey, the Soviet Union, and Israel. Much of Aron's best work has focused on the changing face of Jewish neighborhoods and communities in America, especially the Lower East Side of New York and Venice, California. His training as a sociologist and his natural sensitivity to his subjects have made Aron's photographic work in vanishing Jewish communities some of the best-known and most widely shown.

With this in mind, Aron was commissioned by the Museum of the Southern Jewish Experience, near Jackson, Mississippi, to photograph a series for its inaugural exhibition, "Images of Southern Jewish Life," in 1989. Aron's assignment was to document the "southern Jewish experience" and to capture through the art of photography images that were uniquely southern and Jewish. Like the Jewish world of New York's Lower East Side, southern Jewry has been transformed as southerners migrate from the small towns that their immigrant families helped settle in the late 1800s and early 1900s to larger cities in the South and elsewhere throughout America.

Southern Jews have embraced many rich regional traditions, just as Jews have done in other parts of the country and the world. To be a Jew in the South has unique meaning. Family and home life provide the occasions for this pronounced blend of Jewish and southern cultures.

Menorah and Magnolias captures such a moment, with characteristic home-centered ritual and distinctive regional symbolism evocative of the spirit and customs of the Jewish South. A young southern Jewish mother tenderly kindles the Hanukkah lamp with her daughter. A Hanukkiah is perhaps the single most defining Jewish object in the South. One is found in every southern Jewish home. The lamp represents Jewish continuity as well as the separateness often felt by Jewish people wherever they have lived as a distinctive minority culture, as they do in the South.

This photograph highlights the fundamental Jewish value of transmitting the customs of Judaism from generation to generation, capturing a parent handing down sacred Jewish traditions to keep them alive in all places, at all times. The graceful magnolia, the official state flower of Mississippi, symbolizes the strength and beauty for which the South is especially renowned. The people of this beautiful and fertile region have intense pride in their own time-honored values and traditions. By using such strong visual images from seemingly disparate cultures, the artist has captured the sanctity of both, the harmony of the moment, and the enduring traditions Jews have kept alive throughout the centuries. As prescribed by ancient Jewish law, this contemporary family kindles their Hanukkah lights in a window, proclaiming the miracle for all to see.

Silver gelatin print. 16 x 20 in. (40.6 x 50.8 cm). Collection of the Museum of the Southern Jewish Experience.

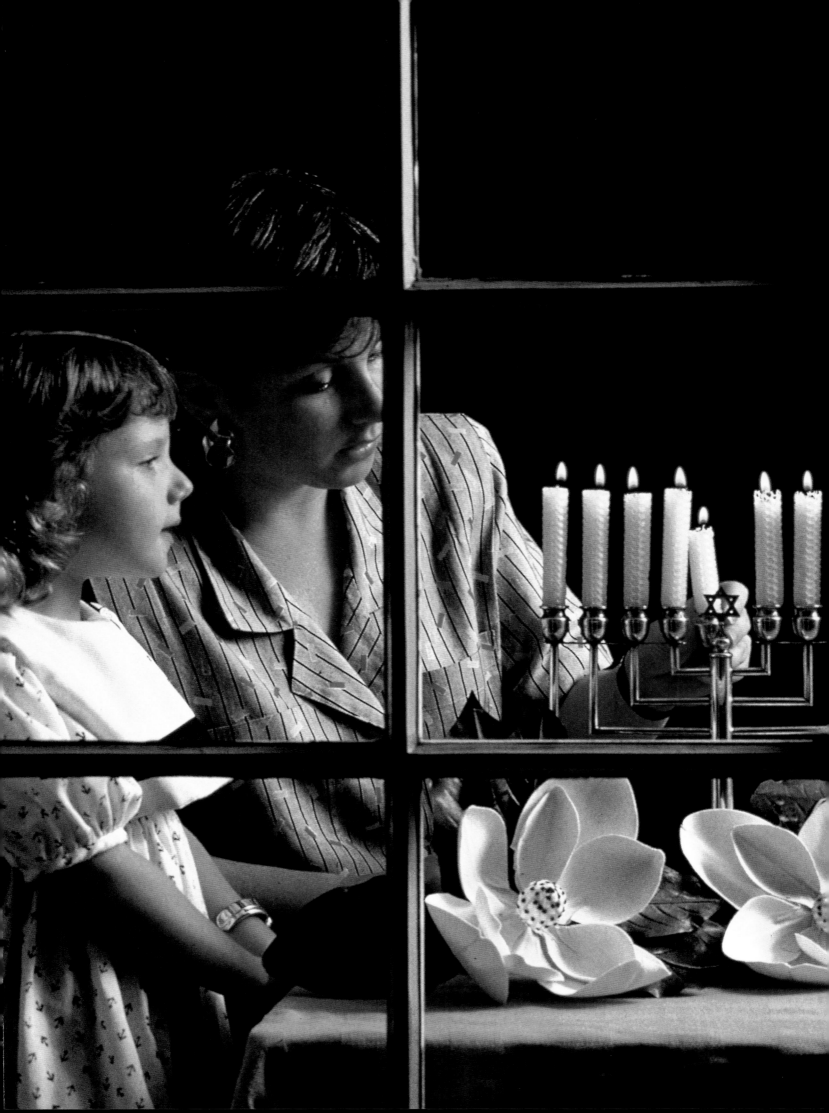

INDEX

Page numbers in *italic* indicate illustrations.

A

Aaron Pouring Oil into the Menorah (British Museum Miscellany), 15, 16, 22, *23*, 46
Abbey Church of Vierzehnheiligen, *50*
Anson, Manfred, 84, *85*
Antiochus, 9, 34, 70, 90
Aron, Bill, 17–18, 114, *115*
Azouly, Danny, 106

B

Baskin, Leonard, 16, 102, *103*
Benjamin, Chaya, 48
ben Yekutiel ha-Kohen, Moses, 26
Bezalel Art School, 80
Blessing books, 42, 44
Boller, Johann Adam, 40, *41*
Boller lamp, 12, 15, 40, *41*
Botticelli, Sandro, 28, *29*, 30
Brandeis, Louis, 18
British Museum Miscellany, 22, *23*
Brody Lamp, 13, 14, 50, *51*, 76

C

Calligraphy, 17, 86–87, 102–103
Cervera Bible (Joseph ha-Zarefeti), 10, 12, 15, 16, 20, 21
Chair lamp, 66, *67*
Coin, *11*, 11–12
Contemporary dreidels, 18, 106, *107*

D

Damascene lamp, 74, *75*
de Levis, Joseph, 32, *33*
Deuteronomy, book of, 48
Donatello, *40*
Dreidels, 18, 70, *71*, 106, 107

E

18th-century Dutch Lamp, 14, 48, 49
Elkan, Benno, 82, *83*
Exodus, book of, 10, 12, 20, 22, 82

F

Feldman, Bella, 98, *99*
Feldman, Kerry, 16, 108, *109*
Felsenhardt, K., 17, 68, *69*
Festival of Lights, 9, 22, 88, 104
First Temple, 22
Florentine Renaissance, 26
Furman, Jacobo, 76

G

Gattman, Leslie, 106
Genesis, book of, 72
Great Synagogue of Amsterdam, 46
Grisaille, 64
Grossman, Cissy, 24
Gruss, Alex, 112, *113*
Gruss, Lorelei, 112, *113*
Gundersheimer, Hermann, 62

H

Hamburg Miscellany, 10, 34, *35*

Hamsa lamp, 14, 72, *73*

Haneirot Halalu: These Lights Are Holy, 102, *103*

Hannah, 16, 34, 102, 112

Hannah and Her Seven Sons (Hamburg Miscellany), 16, 34, *35*

Hanukkah, history of, 9–10

Hanukkah in New York (Zeldis), 17, 104, *105*

Hanukkah Lamp in Four Levels (Segal), 96, 97

Hanukkah Still Life (Koblitz), 17, 110, *111*

ha-Zarefeti, Joseph (Joseph the Frenchman), 20, *21*

Heilperin lamp, 14, 36, *37*, 58

Henschel, Johann Philip, 42, *43*

Herzl, Theodor, 10, 80

Hillel school, 11

Hirsch, Samuel, 60

Hirsch lamp, 13–14, 60, *61*

History of the Jews (Josephus), 9

"Holiday Celebration" series of United States postage stamps, *16*, 18

Holofernes, 16, 26, 28, 32, 40, 44

I

In Days of Old, at This Season (Gruss and Gruss), 112, *113*

Islamic art, 14, 54, 72, 74

J

Jewish Cultural Reconstruction, Inc., 62

Josephus, 9, 26

Josippon, book of, 26

Joy of Hanukkah, The (Schwartz), *17*

Judah the Maccabee, 9, 12, 26, 32, 70, 82, 86, 96, 112

Judah the Maccabee (Rothschild Miscellany), 16, 26, *27*

Judah the Maccabee lamp (Elkan), 82, *83*

Judith, 16, 26, 28, 32, 40, 44

Judith, book of, 28, 32

Judith (Botticelli), 28, *29*

Judith and Holofernes (Rothschild Miscellany), 16, 26, *27*

Judith and Holofernes (Book of Blessings), 44, *45*

Judith and Holofernes (Donatello), *40*

K

Kaballah, 112

Karlskirche (Church of Saint Karl Barromaeus), Vienna, *60*

Karo, Joseph, 102

Kindling of the Hanukkah Lights, The (Oppenheim), 17, 64, *65*, 66

Kings, book of, 20, 22

King Solomon's Temple, 20

Koblitz, Karen, 17, 110, *111*

L

Lamp That Burned On, The (Ruffner), 16, 100, *101*

Landsberger, Franz, 56

Lehman/Figdor lamp, 12, 14, 24, *25*

Lighting the Hanukkah Lamp (Felsenhardt), 12, 68, *69*

Lions of Judah, 50, 74, 76, 80

Los Angeles lamp (Shire), 16, 94, *95*

M

Maccabees, 9, 10, 16, 18, 20, 22, 28, 44, 78, 82, 84, 90, 92, 96, 98, 102, 108

Maccabees, books of, 9, 34, 102

Maimonides, 14, 52, 102

Masada Lamp (Zabari), 16, 88, *89*

Mattathias (father of Judah the Maccabee), 9

Mattathias Antigonus, 11, 12

Meander lamp (Feldman), 16, 108, *109*

Medici, Piero, 28, 40

Menorah brand Hanukkah candles (Raban), 80

Meier, Richard, 16, 92, *93*

Meier lamp (Meier), 16, 92, *93*

Meir, Golda, 10, *15*

Memphis design movement, 94

Menorah and Magnolias (Aron), 17–18, 114, *115*

Michelangelo, 32

Mintz Collection lamp, 78, *79*

Mirador de Lindaraja, Alhambra, Granada, *54*

Mirror lamp, 58, *59*

Mishneh Torah, 102

N

Narkiss, Bezalel, 24
Narkiss, Mordechai, 66
Natzler, Gertrud, 90
Natzler, Otto, 16, 90, *91*
Natzler lamp, 16, 90, *91*
19th-century wooden dreidels, 18, 70, *71*
North African lamps, 12, 54, *55*
Numbers, book of, 48

O

"Oak Tree" lamp, 56, *57*
Oil lamp, *13*
Oppenheim, Moritz, 17, 64, *65*, 66, 68

P

Palazzlo della Signoria, Florence, *30*
Palazzo lamp, 12, 14, 30, *31*
Passover, 9, 66
Passover Haggadot, 44
Pewter bench-type lamp (Henschel), 14, 42, *43*, 52
Picart, Bernard, 17
Pictures of Old-Time Jewish Life (Oppenheim), 64, 68
Polish brass lamp, 14, 52, *53*
Proverbs, book of, 24
Purim, 9

R

Raban, Ze'ev, 80, *81*
Renaissance lamp (Joseph de Levis), 14, 32, *33*
Rintel lamp (Robol), 46, *47*
Robol, Peter II, 46, *47*
Rothschild, Hannah Mathilde von, 62
Rothschild, Wilhelm Karl von, 62
Rothschild lamp (Johann Heinrich Philip Schott Sons), 15, 62, *63*
Rothschild Miscellany, 15, 26, *27*, 108
Ruffner, Ginny, 16, 100, *101*

S

Schatz, Boris, 80
Schoenberger, Guido, 62
Schott, Johann Heinrich Philip, Sons, 62, *63*
Schuler, Johann Valentin, 38, *39*
Schuler, Michael, 38
Schwartz, Michel, 17
Second Day, The (Baskin), 102, *103*
Second Temple, 20, 22
Segal, Zelig, 96, *97*
Seventh Day, The (Baskin), 102, *103*
Shahn, Ben, 12, 86, *87*
Shammai school, 11
Shammash, 12, 22, 24, 30, 66, 92, 98
Shire, Peter, 16, 94, *95*
Shulhan Arukh, 52, 102
Smotrich, Hannah, *16*, 18
Spertus Judaica Prize, 98
Srolovitz, Bonnie, 106
Star hanging lamp for the Sabbath and festivals, 38, *39*
Star of David, 74, 76
Statue of Liberty lamp (Anson), 84, *85*
Synagogue ark lamp, 76, *77*

T

Tablets of the Law, 76
Talmud, 22, 24
Temple lamp (Feldman), 98, *99*
Ten Commandments, 74
Third Day, The (Baskin), 102, *103*
Torah, 9, 24, 92
Two Spies symbol, 48

U

United States postage stamp, "Holiday Celebration" series of, *16*, 18

V

Vienna Secession, 66

W

We Kindle These Lights (Shahn), 12, 16, 86, *87*
Wilderness Tabernacle, 20

Y

Yemini, Yehia, 80, *81*
Yemini Lamp (Yemini), 15, 80, *81*

Z

Zabari, Moshe, 16, 88, *89*
Zechariah, 10, 20
Zeldis, Malcah, 17, 104, *105*
Zionists, 10, 80, 96

PHOTO CREDITS

Mark Akgulian: p. 83
Alinari/Art Resource, NY: pp. 28, 30
Lelo Carter: pp. 69, 111
Sheldan Collins: p. 75
Susan Einstein: pp. 85, 91, 93, 95
John Reed Forsman: pp. 57, 61, 63, 67, 89
Avi Ganor: pp. 43, 49
David Harris: p. 32
Erich Hockley: p. 56
Phil Hofstetter: p. 100
The Israel Museum, Jerusalem: pp. 11, 81
The Jewish Museum/Art Resource, NY: pp. 38,
 41, 51, 71, 79, 87
Erich Lessing/Art Resource, NY: p. 60
Myron Miller: p. 103
Zev Radovan: p. 11
Scala/Art Resource, NY: pp. 40, 50, 54
Malcolm Varon: pp. 24, 38